Critical
Dictionary

edited by
David Evans

black dog
publishing

london uk

A

Algeria

Algeria: Anger of the Dispossessed (Yale University Press, 2007) is co-authored by historian Martin Evans and journalist John Phillips who are both specialists in Algerian affairs. We asked Martin Evans to comment on some of the figures that crop up in their ambitious book.

Saint Augustine/ Born into a down-at-heel but well respected Roman family in Thagaste, modern-day Souk Ahras on the border between Algeria and Tunisia, in AD 354, St Augustine was one of the major figures of late-antiquity and indeed world philosophy. After his midlife conversion to Christianity, he sought to reconcile the ideas of Ancient Greece and Rome with the precepts of the Christian faith, a spiritual journey that produce two literary and religious masterpieces—*Confessions*, the world's first autobiography, and *City of God*, in which he argued that humanity lives in one of two cities: the city of God, symbolised by Jerusalem, or the earthly city, symbolised by Babylon. St Augustine died in AD 430.

Under French colonial rule the Roman Catholic Church used his memory to uphold Algeria as a Christian land that had been usurped by Islam, thereby making colonialism into a 'return' rather than an invasion. In contemporary Algeria President Bouteflika has claimed St Augustine as the father of the Algerian nation, a saint who belongs to Islam as much to Christianity. This is an example of historical anachronism. Algerian nationalism is a modern phenomenon even if St Augustine referred to himself as an African and had a close affinity with the Atlas mountains that have marked so much of Algerian culture. For St Augustine these mountains were symbolic of God's constant presence in the world.

Houari Boumediène/ After independence in 1962 Boumediène took power in June 1965 in a well-planned military coup. His seizure of power enshrined the army as the dominant force in Algerian politics. Initially greeted with indifference by the population Boumediène rose to become one of the great leaders of the third world non-aligned movement, addressing the UN in 1974 calling for a redistribution of wealth to the poor south. Boumediène died in 1978 and has become a figure of nostalgia for many Algerians. They remember his period of rule as a moment when Algeria stood tall on the world stage.

Abdelaziz Bouteflika/ Bouteflika is a veteran politician who was the Algerian ambassador at the UN during the 1960s and 1970s. In April 1999 he returned to the centre stage when he was elected president albeit in dubious circumstances. Through a policy of reconciliation Bouteflika has attempted to bury the violence of the

Martin Evans, *Algeria: A Little Biographical Dictionary*, 2008.

1990s. However, his attempts have been hampered by continuing social and political unrest. In popular parlance Bouteflika is referred to as "made in Taiwan", a joke that recognises that his power is limited by the generals and security chiefs who operate behind the scenes.

Frantz Fanon/ Fanon is one the major thinkers of the twentieth century. His writings are key to the debate on colonialism and post-colonialism. Born in 1925 in Martinique, Fanon fought with the Free French in Italy before going on to study psychology at Lyon University in the late 1940s. In 1953 Fanon began working as a psychiatrist in Blida just south of Algiers. In treating Algerian patients he came to interpret their mental health problems as the consequence of French rule. In this way he came to understand colonialism not just as a question of economics but also psychological and cultural domination. In 1956 he resigned his post and joined the FLN in Tunisia working as a journalist for the FLN paper *El Moudjahid*. He died in 1961 shortly after as the publication of his most militant work, *The Wretched of the Earth*.

Abd el-Kader/ France invaded Algeria in 1830 and swiftly overthrew the Ottoman regime which had been in place since the early sixteenth century. Although the French claimed to be liberating the local population from Ottoman oppression and although they maintained that they would respect Islam, they met fierce resistance from the Muslim population. In the eastern part of the country this resistance was led by Abd el-Kader, a charismatic 25 year old holy man who called for a holy war against the Christian invaders. Abd el-Kader was eventually defeated in 1847 and went into honourable exile in Damascus. His was to be an inspirational figure for twentieth century Algerian nationalism and in 1967 his ashes were brought back from Syria for a state burial.

Souad Massi/ Souad Massi is a folk singer who was driven into exile in France in 1994 after being threatened by Islamists. Singing in French and Arabic much of her music confronts the violence of the 1990s, speaking eloquently about civilian pain and suffering.

Le Micro Brise le Silence/ Four rappers, Redone, Yacine, Med and Rabah, emerged in Algiers in 1993, drawing upon Algerian oral culture as well as US and French rap. Their first cassette, released in 1997, sold over 60,000 copies. Inspired by the novelist Tahar Djaout, assassinated in 1993, their starting point was the refusal to be silenced. Through the spoken word they wanted to bear witness to official amnesia and the hellish existence of their generation.

Pépé le Moko/ Julien Duvivier's 1937 gangster film set in the Algiers casbah. Starring Jean Gabin as Pépé, the French criminal on the run from the police and holed up in the casbah, the film is shot through with ambivalences about the colonies. The casbah is a site of fear and fascination, whilst Pépé hardly fits the stereotype of the French colonial lording it over the natives. Psychologically unhinged by his predicament he commits suicide at the end of the film.

Gillo Pontecorvo/ Italian director whose 1966 film *The Battle of Algiers* was shot within the casbah and recreated one of the key events in the Algerian War: the battle between the National Liberation Front (FLN) and the French paratroopers between 1956 and 1957. Drawing on much of Fanon's arguments, especially the scene where the Algerian women disguise themselves as French in order to plant bombs in the European quarter, the film achieved an iconic status within 1960s radical counter-culture.

Archie Shepp/ Shepp famously performed at the first ever Pan-African Cultural Festival in Algiers at the end of July 1969. Playing off a group of Tuareg musicians his free-form set broke away from the European derived harmonic system that had been a model for an earlier jazz generation. His intention was to recover the African roots of jazz, making explicit the relationship between culture and militant politics.

Rachid Taha/ The child of Algerian immigrants to France—his father crossed the Mediterranean from Oran in the 1970s—Rachid Taha shot to fame in the 1980s as the lead singer in an immigrant band, whose name Carte de Séjour (Residency Permit) was a provocative response to the rise of Jean-Marie Le Pen's far right National Front. The intertwining of France and Algeria is at the core of Taha's work. His cover of Charles Trenet's "Douce France", an iconic song in the French popular canon, showed his Algerian band strumming in a late night Parisian cafe, surrounded by old French couples waltzing to the tune. The message: there is no going back; or, we are here to stay.

Zinédine Zidane/ Talismanic mid-fielder who won the World and European Cups with France in 1998 and 2000 respectively. Nicknamed Zizou, from La Castellane in northern Marseille, the son of Algerian immigrants, he has been voted the most popular French person of all time. Yet, as a popular Algerian joke goes, why is Zidane French whilst Khaled Kelkal, a terrorist suspect shot by French police in 1995 but also born in France of Algerian parents, is Algerian?

A

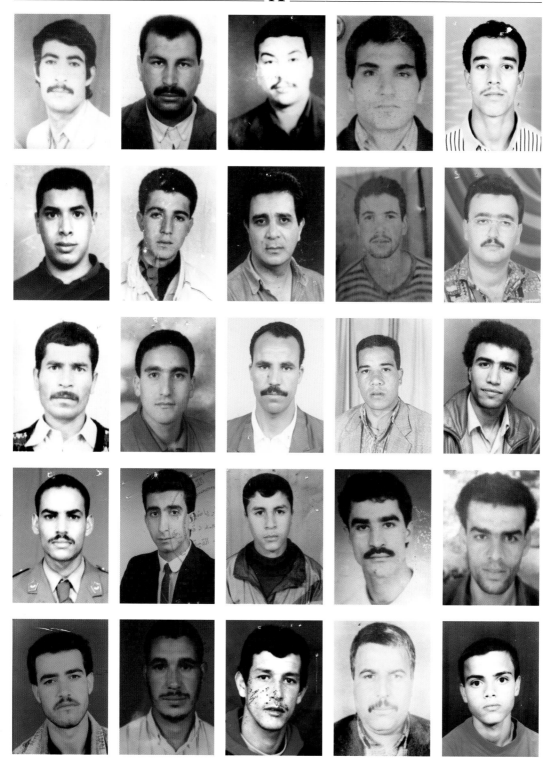

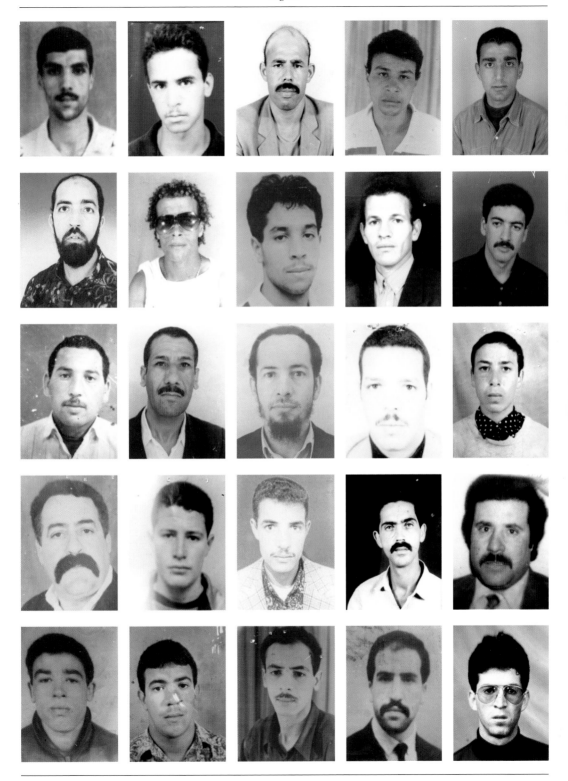

Omar D, *Devoir de mémoire/A Biography of Disappearance, Algeria 1992–*, 2007.

Appropriation

Candice Breitz, *Soliloquy (Sharon)*, 2000.

DAVID EVANS: Are you trying to change the world?

CANDICE BREITZ: I'm trying to be changed by the world.

DE: Is your life a movie?

CB: No.

DE: Are you searching for a new alphabet in the language of cinema?

CB: Absolutely.

DE: Is it good to steal?

CB: It depends what you steal and why.

DE: Is your entire career an assault on the notion of intellectual property?

CB: I like to think there's a little more to it.

DE: Do you just have two themes: death and the impossibility of love?

CB: Did you take mind-altering drugs between this question and the last?

DE: Or Walt Disney plus blood?

CB: ... and have a bad trip?

DE: To show and to show yourself showing—is this a succinct formulation of your fundamental aesthetic?

CB: No.

DE: Are you an entymologist filmmaker?

CB: I'd say I tend more towards etymology than entymology.

DE: Are your films like a battleground—love, hate, action, violence, death. In a single word: emotion?

CB: Are you having a lurid flashback?

DE: Is a good film a matter of questions properly put?

CB: Certainly.

DE: Would you say that you work like an amateur in a professional way?

CB: Yes. I haven't yet figured out how to work like a professional in an amateur way.

DE: Do you make films on politics or political films?

CB: I do not make films at all.

DE: Are you looking for love through work?

CB: No.

DE: Do you offer a just image or just an image?

CB: Neither of the above.

DE: Is ours the civilisation of the arse?

CB: Whose arse do you have in mind Mr Evans?

DE: Do you prefer Marx or Coca Cola?

CB: Marx: he's less sticky and more fluid.

DE: Are your films truth 24 frames a second?

CB: I'm terribly sorry to say that I don't make films.

DE: Do you just need a girl and a gun to make a film?

CB: I really don't make films!

DE: Why bother with an interview?

CB: I hoped the questions might be more Marx and less Coca Cola....

David Evans, *Wind from the East: One or Two Questions for Candice Breitz*, 2009.

DAVID EVANS: Your book is in the *Very Short Introduction* series, launched by Oxford University Press in 1995, and sits comfortably between *Apocryphal Gospels, The* and *Archaeology* in an A to Z list of more than 200 titles. It reminds me of others in the series— Steve Edwards on photography, Julian Stallabrass on contemporary art, or Robert Young on postcolonialism, for example—where the author has produced a guide that is concise and accessible, but never simplistic. Could you say something about the difficulties of writing a very short introduction to a tricky topic like appropriation?

ANN LEE: There are difficulties in writing a very short introduction to just about anything, no? I'm awestruck every time I look at the other titles in the series. *Free Will? Economics? The Meaning of Life?* Now that's a tricky topic!

Do you know the series' slogan? Other than "Brilliantly Concise?" It's "Where's the gap in your knowledge?" You're encouraged to take an online quiz to find out [http://www.veryshortintroductions.co.uk/flash.php]. Get two out of three questions right and you're assured that you don't have to learn anything more about culture or politics or science or what have you. Yet as an author of a Very Short Introduction, one is contributing to a never-ending project— but is that unfinished task the original mission of Bouvard and Pécuchet or the final endeavour of Flaubert?

Which leads right back to your question about appropriation, handily enough. I felt that the book needed to be written because it's such an enormous topic, although perhaps it's more accurate to say appropriation is simultaneously vast and miniscule. The word belongs to so many histories that confusion appears inevitable. And we can't have that, of course. So this anxiety tends to lead to oversimplification, even within more structured divisions. In art, for example, appropriation has become a blanket term. Take a look at artworks that have been assigned to this category, and it doesn't take long to see the tremendous degree to which they vary. I don't mean to imply that the term should be struck from our lexicon, only that we must refuse to mute dissonance for the sake of an artificial—if comforting—clarity.

One of the greatest difficulties I faced was how to give a sense of the enormity of the topic while maintaining the sort of specificity crucial for future studies of appropriation. The case study emerged as the most practical strategy for

achieving something approximating this end. The unexpected case study seemed even more promising, though it is likely that some will be frustrated by the lack of attention to figures like Duchamp and Warhol.

Of course, the method produced as many predicaments as it resolved. During the writing process, I sometimes felt like my mind was in disagreement with itself, which you can detect in the book—by no means is it a seamless text. But I don't think that has to be such a nightmare. It might even engender some productive possibilities.

I'm surprised that you describe the book as something that "sits comfortably", by the way. I'll have to think more about whether that means that the project is a failure or a success.

DE: You offer six chapters, each of around 20 pages. Chapter one offers some preliminaries, reminding the reader that a history of appropriation can be written in a number of ways. A short version could begin with the Pictures Generation, starting out in New York in the late 1970s; an intermediate version begins with Duchamp and the readymade in the early twentieth century; and your longer version foregrounds the quotational approach to painting pioneered by Manet in the nineteenth century. And then chapter two deals with a very long version in which readers are reminded that taking without authority has always been an integral element of conquest and colonialism. Do you have any further thoughts on the problems of periodising appropriation?

AL: The argument about periodising appropriation breaks two ways. On the one hand, the critical term "appropriation" clearly has a history of its own, which can be traced in and through the arguments that emerged around the time of the Pictures exhibition (incidentally, the Pictures Generation was recently canonised in an exhibition at the Metropolitan Museum of Art). On the other hand, the strategy of appropriation in art clearly has roots that run longer and deeper than 1977. In my book, I offer a sketch of this "long history", though it's really only a thumbnail sketch. Since writing the book, it has become clear to me that appropriation has existed throughout the history of human art-making as a major, even a primary, tactic. On a very basic level, appropriation is an excellent means of producing novelty in art; it circumvents entirely the whole hocus-pocus of artistic genius, uniqueness, and authenticity. Rather than ask about the radical newness of

appropriation in art, we should be asking why appropriation ever fell from favour as an artistic strategy. What was so attractive about the anti-appropriative concept of artistic novelty based not on plunder and utilisation but instead expressivity and inspiration? Why did it dominate the art-making cultures of Western Europe from the high Renaissance forward, and why has its grip on artists faltered so markedly in recent decades?

DE: Chapter two critically engages with what you term a "panegyric to appropriation": *Postproduction*, 2002, by French critic-curator Nicolas Bourriaud. Indeed, hostility to Bourriaud seems to be a red thread running throughout the book. Why?

AL: Let me say first that I found Bourriaud's book incredibly smart and timely. (It's also dashingly cute—you have to admit the production size is precious.) Bourriaud details an impressive number of artists whose diverse work operates, in some way, on the postproductive credo of "using what we already have"—a green theme for which I'm all in favour, by the way. (Perhaps it's not just the globalisation of information that gave rise to postproduction, but also a growing consciousness of recycling!) My kvetch with Bourriaud, which I suppose spilled out into much of my book, was that in this smart, descriptive, precious little book, there was no glimpse of a critical postproduction: ne'er a nod to the imbalance of power risked in acts of appropriation, ne'er a wary eye cast toward the commodification of supposed "world heritage". In my second chapter I tried to offer reminders of times when "using what we already have" translated as stealing and outright violence for groups of people who had no power to keep the appropriator out; I also wanted to question Bourriaud's breezy "we" and "our" and other collective assumptions that blur very real differentials of power. Perhaps my book reacted too harshly to Bourriaud, but in that way a reader, the semionaut surfing the publication world on appropriation, can mix my caveats with Bourriaud's panegyric and piece together a more critical look at postproduction.

DE: Another red thread is—conversely—admiration for the writings of Soviet literary scholar Mikhail Bakhtin, especially his essay "Discourse in the Novel". Could you clarify how Bakhtin is relevant to discussions of appropriation art?

AL: Who doesn't love a chain-smoking Soviet scholar? But in all seriousness, Bakhtin's heteroglossia helps liberate appropriation from its conventional one-way narrative: an artist, coloniser, (meta-) consumer borrows, remakes, recycles an object or a sign, creating out of it a work that is fully hers. "Discourse in the Novel" proposes that the appropriated, too, has agency; that it can stubbornly defy or quietly elude its coloniser's intentions; and that, ultimately, not all codes and forms can be seamlessly seized and inhabited. Most importantly, perhaps, Bakhtin suggests that appropriation can never be neutral or ahistorical; indeed, in claiming the discourse or object of another, the artist surrenders any pretense of autonomy.

DE: What's the train of thought in the third chapter that presents Manet as the first appropriation artist?

AL: First, let us accept that beginnings can serve any number of functions—they can frame or order a topic, they can reveal objections and equally conceal intentions—but often, they are conceits. Admittedly, they are earnest conceits. When confronted with the task of generating an introduction to appropriation (*nota bene*: I do not make claims for a history of appropriation, which would be, I believe, an entirely different creature, and no doubt encyclopedic in shape) it became clear that a point of origin, a beginning, would need to be located in order to structure the narrative arc of the text.

Does that sound painfully arbitrary to you? Aren't all beginnings mundane in shape and essential in function? It was clear that the phenomenon of appropriation operated to varying degrees throughout the modern period—it was a matter of deciding where to intervene. For this beginning would be called on to act as a pedigree for appropriation's shape shifting shenanigans. So, as you can see, what was needed was a point of departure and an authenticating genealogy—enter Manet.

Why Manet? I haven't forgotten the question, nor its relevance. Why not begin with eighteenth century models of emulation? The practice of the copy? Typological transmission throughout the early modern period? Or, for that matter, why not begin with Cubism? With collage? With Braque and *faux bois*? Why Manet? Let me answer in this way: because Manet pares down the issue of quotation, he focuses the act

of appropriation, and frames it as a calculated artistic gesture. Manet understands what it is to make the act of borrowing styles, figures, compositional schema, and tropes an exposed move. He strips bare the architecture of copying and emulation in order to reveal the underlying art-historical *telos* as open for revision and critical refashioning. In this sense, Manet denaturalises the tradition of the copy; he makes borrowing, quotation, repetition a critical strategy—that is, the tremors of appropriation.

In many ways this text accepts, I think, that appropriation exists as a preeminently postmodern strategy (*per* Douglas Crimp). Yet, the appropriative gesture's penchant for self-reflexivity, its critical sense of play, emerge in the modern moment. Manet serves, here, as a point of departure precisely because he understands the original model, the beginning, we might say—as embodied by, for example Giorgione or Titian—as a conceit. But, admittedly, they are earnest conceits.

DE: Chapter four deals with the Situationists and their legacy. Could you clarify your basic distinction between Situationist *détournement* (a hard-working French word whose meanings include corruption, diversion, embezzlement and hijacking, depending on the context) and contemporary culture jamming as practised by Adbusters or The Yes Men?

AL: While both the Situationist tactic of *détournement* and culture jamming use pre-existing sources to disrupt the existing order of the spectacle, the basic distinction between the two is the degree of trust in the criticality of this gesture and an awareness of the possible re-assimilation of these acts of appropriation into the spectacle. In the 1990s, groups such as Adbusters and The Yes Men appropriated the language of commodity culture and mainstream media outlets by way of performances and visual language that employed pun and parody—an efficacious and attention-grabbing form of interference which, while effectively exposing the frills of spectacle culture, remained vulnerable to re-appropriation by the very mechanisms of the spectacle that culture jamming sought to subvert. The Situationists, by contrast, remained always aware of the re-assimilating powers of the all-consuming spectacle. They distanced themselves from avant-garde movements that claimed to critically transcend originality and authorship and instead used references to 'original' sources only to show the inertia of images and

objects wholesale. This led to Debord's eventual rejection of art as a means to his revolutionary ends.

DE: Chapter five returns to New York in the late 1970s and early 1980s when the term appropriation began to pervade writing on contemporary art. In what way is this chapter a revisionist history?

AL: What does it mean to re-tell the "history" of appropriation art in the 1970s and 1980s? The art of that period already imagined itself in terms of a historical narrative, posed in terms of a historical break, a rupture. It took itself to instantiate the divide between something called "modernism" and "postmodernism". Sherrie Levine's work, for example, consisted in that period in a retrospective look at the work of modernist masters. This retrospective look was at the same time a launching into the future. It is an exact copying that performatively puts a history into play. It inserts a difference, defined on a temporal axis: this "postmodernism", a photograph by Sherrie Levine, exactly resembles that modernism, a photograph by Walker Evans. But in this resembling, it testifies to the movement of history, it is that movement, it creates or instantiates it. To something, an image, that appears spatially identical it adds a temporal dimension.

This work of "historiography", then, seems to be inherent to the work of "appropriation". In this chapter, I do not so much seek to overturn the self-narration of the art and criticism of the period as to sound out its mode of operation. I do this in terms of the linguistic category of "irony", which installs a temporal axis along which lies the distinction between an utterance, or an image, and its (ironic) reiteration. At the same time, I ask if there are certain things that our retrospective look now at a moment itself defined by an activity of retrospection (the re-iteration of pre-existing images) changes in the way that activity appears to us, the narrative of history it sets in motion. The history that appropriation art narrates is a history that comes into focus through photography—and the critical rubric of 'representation'—which emphasises structures of signification, not the materiality of objects. So in this chapter, I turn to Haim Steinbach, whose work failed to impress Douglas Crimp or Craig Owens, for instance. I ask why that work could not appear important in terms of the narrative they were busy crafting in conjunction with the artists they did write about. At the same time, I wanted to point

out that appropriation took many forms, beyond what is normally included within the term "appropriation art". It is a matter of asking how any given narration creates and delimits the terms which make its narrative plausible. We can only do this in hindsight. So yes, to that extent it is a revisionist history, but not one that contradicts the existing narratives, rather one that explores them from within—within the art they produced and explained—as well as from within their silences.

DE: In your concluding chapter you seek to identify new directions for appropriation art in the recent work of figures like Coco Fusco and Guillermo Gómez-Peña, or Andrea Fraser. What is their significance?

AL: Very simply put, these artists all engage in appropriation under the banner of performance; and their performances take the art museum (or the "art institution") as a necessary site of struggle. This seemed to me a vital strand of contemporary appropriation art, but since it's not premised upon picture-making, its status as appropriation is easy to miss. Also, the practices of these artists set a crucial precedent for many of the most audacious performance-appropriators of the present-day: The Yes Men, for example. At the University of California, Berkeley, where I'm currently based, a group of students recently founded a performance group to protest—or, in their own official, appropriated discourse, to support—the recent round of budget cuts and fee hikes. Their official name is UCMeP—UC Movement for Efficient Privatization. They're the direct inheritors of Fusco, Gómez-Peña, and Fraser.

DE: There are a lot of Ann Lees out there, including the eighteenth century Shaker, the Europop star who had a big hit with "2 Times" in 1998, and the Manga character whose copyright was bought by artists Philippe Parreno and Pierre Huyghe in 1999. Do people get confused about your identity?

AL: Questioning identity is so twentieth century.

DE: Hocus-pocus. Practical jokes. Tom-foolery. Whatever you call it, the historic avant-gardes enjoyed a good hoax. Do you?

AL: *Credo Quia Absurdum.*

(Ann Lee, *Appropriation: A Very Short Introduction* is available from Lulu.com.)

Bed

David Campany, *Bed*, 1995.

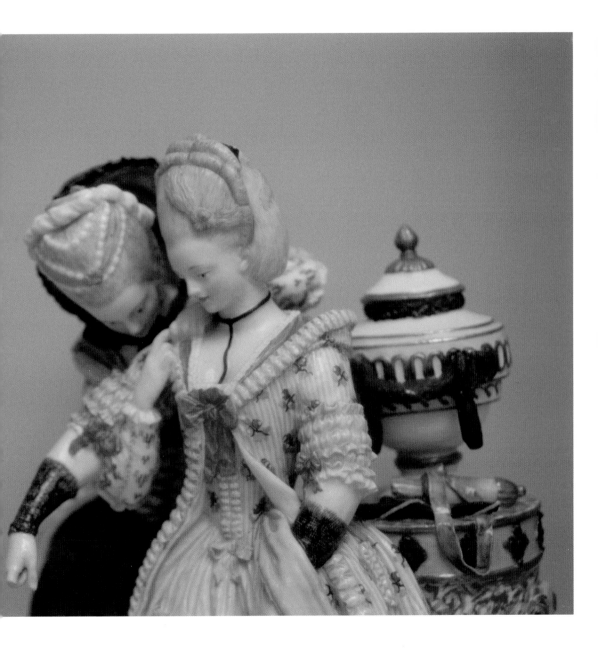

Birgitte Sigmundstad, *Philosophy in the Boudoir*, 1999.

Border

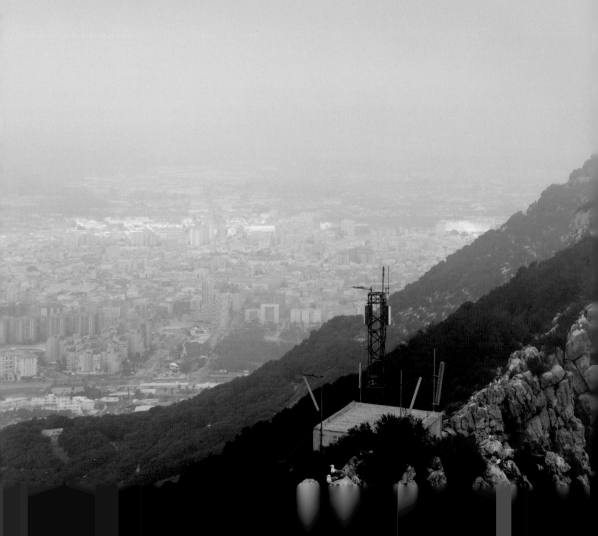

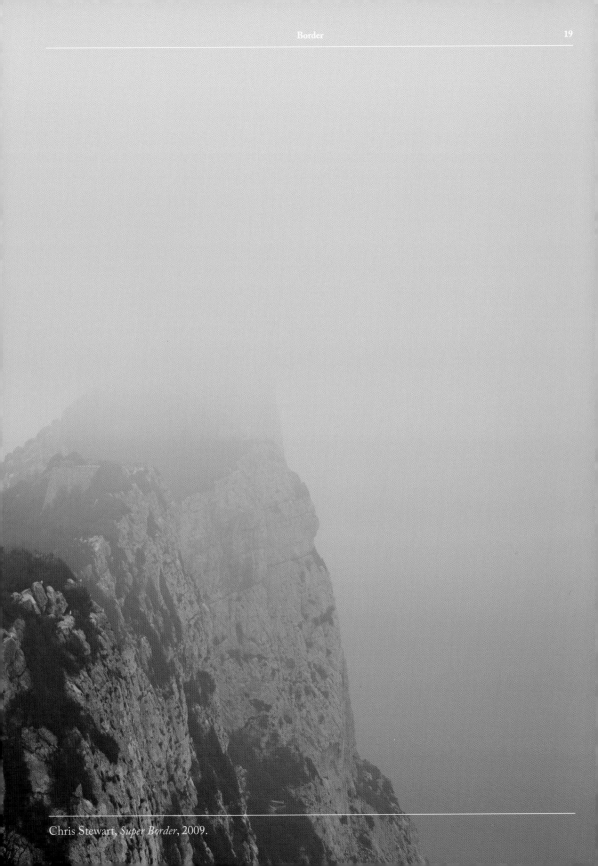

Chris Stewart, *Super Border*, 2009.

B

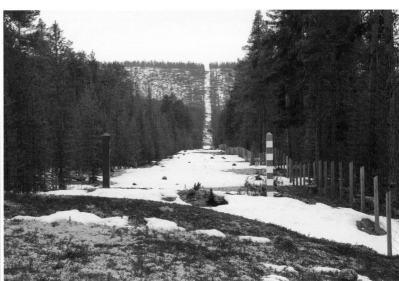

top row/ Mark Roberts and Minna Rainio, *Borderlands*, 2004.
bottom row/ Chris Stewart, *Super Border*, 2009.

B

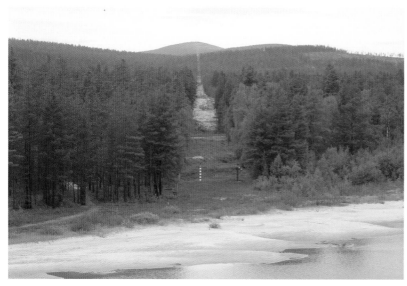
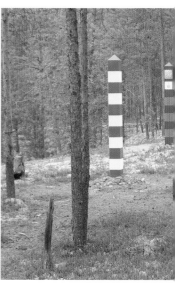

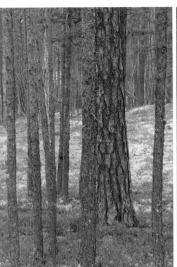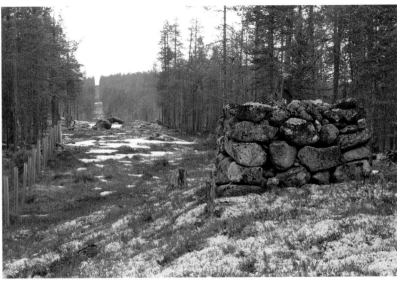

top row/ Mark Roberts and Minna Rainio, *Borderlands*, 2004.
bottom row/ Chris Stewart, *Super Border*, 2009.

UN SPLENDIDE PAYSAGE QUE BERNARD BUFFET A SOUVENT PEINT

Cartography

Asger Jorn and Guy-E Debord, *Fin de Copenhague*, 1957.

La Disparition is a collage based on photographs of the platform maps found at Métro stations in Paris. Owing to the "tactile reference", stations are effaced in a way that is different every time, depending on the more or less frequent consultation carried out by passengers. The whole map has been reconstructed from these images.

How should we take account of, question, describe what happens every day and recurs every day: the banal, the quotidian, the obvious, the common, the ordinary, the infra-ordinary, the background noise, the habitual?

Georges Perec, *Approaches To What?*, 1973. Paola Di Bello, *La Disparition*, 1994.

C

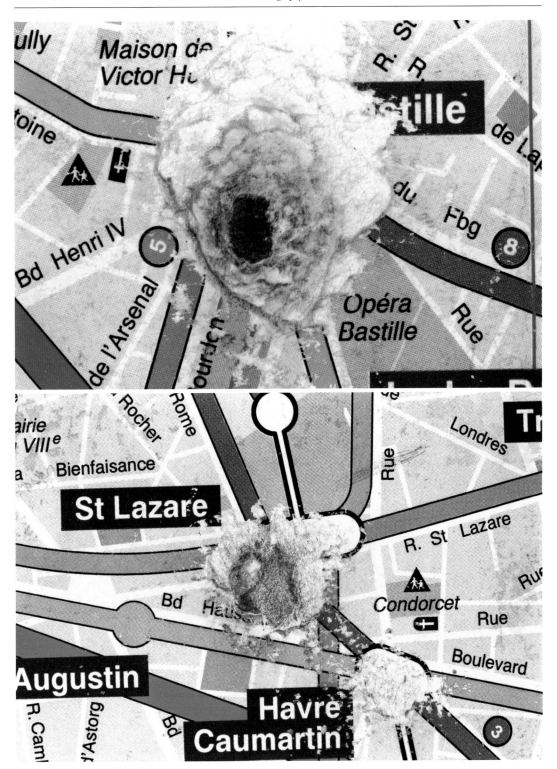

opposite and above/ Paola Di Bello, *La Disparition* (details), 1994.

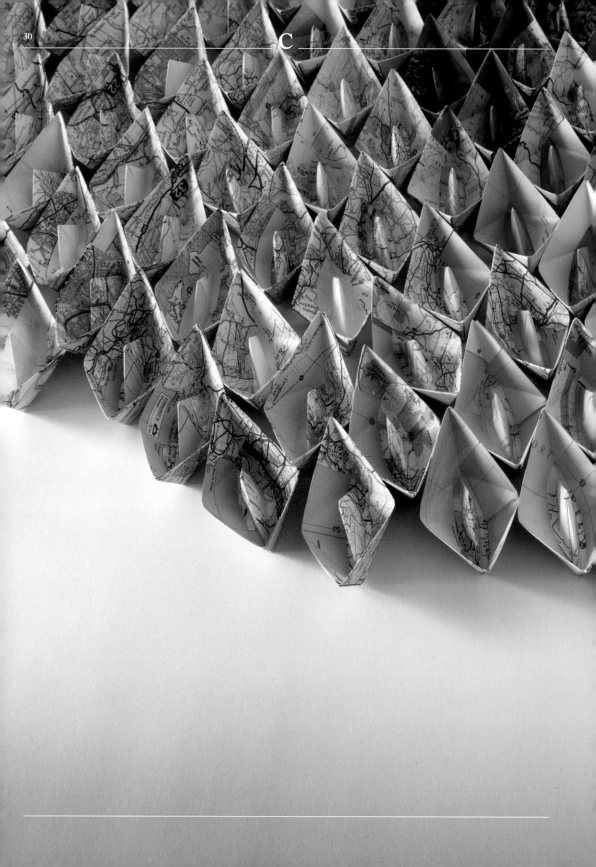

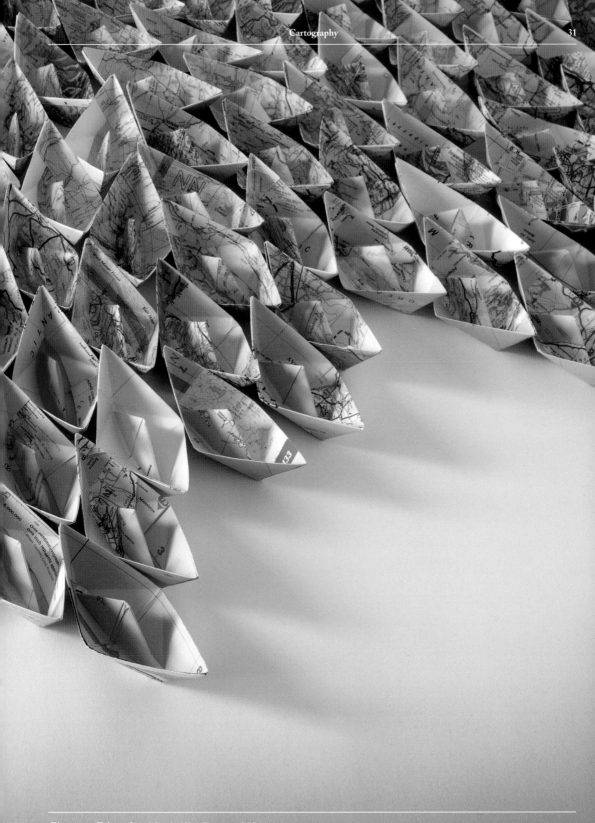

Christian Edwardes, *North-West Passage*, 2006.

Civilisation

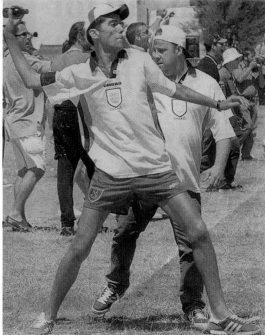

Poor Photographer, *Civilisation*, 1998.

Comm(e)unism

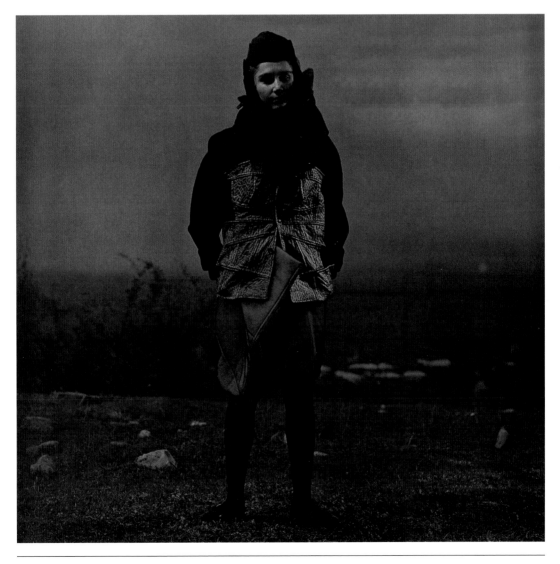

Brian Griffin, *Untitled*, 1990.

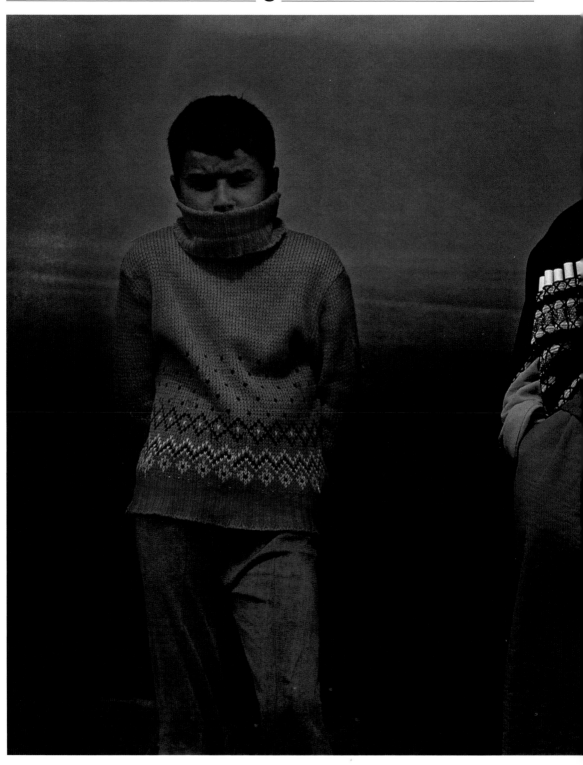

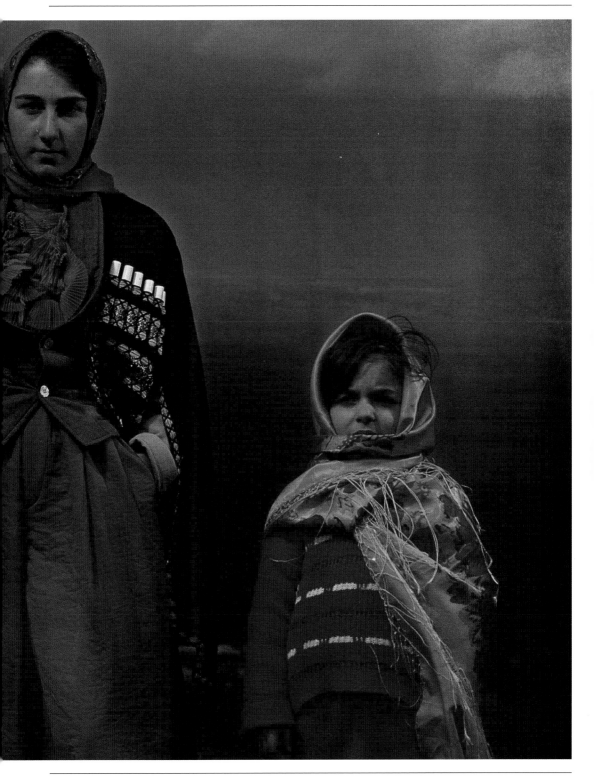

Brian Griffin, *Untitled*, 1990.

C

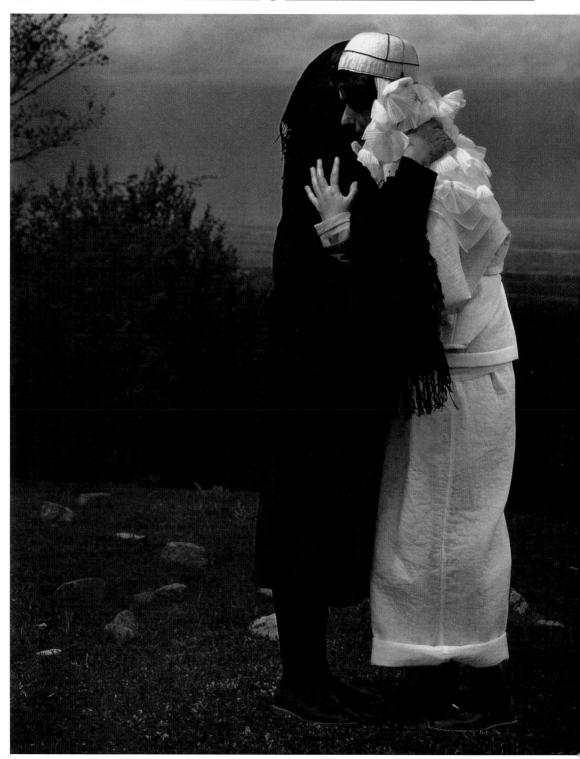

Brian Griffin, *Untitled*, 1990.

Photographer: Brian Griffin. Stylist: Rei Kawakubo, boss of Japanese fashion house Comme des Garçons. Location: Soviet Georgia in Winter 1989/1990—a tense moment with political meetings on street corners and armed soldiers protecting statues of Stalin. (Georgia was to become an independent republic in April 1991.)

No professional models were used. Instead, the team worked with local peasants, often wearing their own clothes, sometimes supplemented by a Comme piece. The photographs appeared in *Six*, an extravagant magazine published by Comme that was given away free to top customers.

In Eisenstein's films, Capitalism (The Old) is inevitably superseded by Soviet Communism (The New). But by 1989, the Soviet Empire was about to implode and Capitalism (The Old) was soon to triumphantly describe itself as The New. Griffin's photographs brilliantly register this epochal moment in modern history, when The Great Experiment celebrated by Eisenstein is definitively over, and when Comme seems more inspiring than Communism.

David Evans, *Comme and Communism*, 2006.

Dangerous Moment

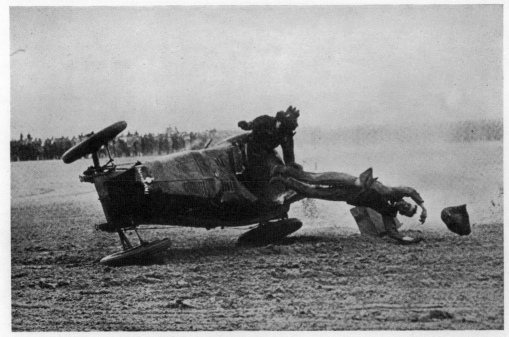

Die letzte Sekunde.

Already today there is hardly an event of human significance toward which the artificial eye of civilisation, the photographic lens, is not directed.

Anon, *The Final Moment*, in Jünger, 1931. Ernst Jünger, *On Danger*, 1931.

Found Photographs, Paul Poinat Collection, 2011.

Détournement

Brussels. May 1956. The Belgian Surrealist journal *Les Lèvres Nues* reveals its stance on the Franco-Algerian War with a cover image that has an outline map of France containing the names of Algerian towns. Efficiently, *France algérienne* inverts and ridicules the rightwing slogan *Algérie française*. The counter-map also ties in with a lead article listed on the cover called "Mode d'emploi du détournement" ("Methods of *détournement*"). *Détournement* has many meanings in everyday French, and here the word is also used to characterise the re-working of pre-existing materials as a radical alternative to creating art. Co-written by Guy-Ernest Debord and Gil J Wolman, the text was to become a key reference point for the Situationist International, officially founded the following year.

Yet on the cover it is credited to Louis Aragon and André Breton. Why? On one level, the false attribution is an example of the hoax, beloved of the historic avant-gardes. One another level, it implies that by the 1950s the founders of Surrealism are viewed by Debord and Wolman as no more dangerous than the other 'authors' on the cover like the Catholic novelist François Mauriac, the pop singer Gilbert Bécaud, the philanthropist Albert Schweitzer and the architect-urbanist Le Corbusier. Nevertheless, the Belgian Surrealist outlet chosen by Debord and Wolman is the most obvious reminder that contempt for Aragon's contemporary role as a cultural mouthpiece for the Stalinist French Communist Party, or for Breton's ongoing attempts to direct the Surrealists from Paris after his return from American exile in 1945, does not involve a straightforward rejection of the movement they launched in 1920s. Rather, Debord, Wolman and their Belgian allies at *Les Lèvres Nues* regret the gap between what Parisian Surrealism once was, and what it had become by the 1950s.

LES
LÈVRES
NUES

SOMMAIRE

N° 8 — MAI 1956. **30 FRS**

Cover, *Les Lèvres Nues*, no. 8, May 1956.

Error

Paul Graham, *End of an Age*, 1999.

A photographic competition was held in France in 1991 called *Fautographique*. It involved around 3,000 amateur photographers who submitted about 10,000 botched images that had failed to make the family album. There was an exhibition and conference in Poitiers involving numerous professionals and, subsequently, 2,157 items were deposited in the Department of Prints and Photography of the Bibliothèque Nationale de France.

The above information is included in *Fautographie*, 2003, by Clément Chéroux, a French photographic historian who edits the journal *Études photographiques*. His title uses the same wordplay (faute/photo, that is, lack or mistake/photograph) as the competition of the early 1990s, but his project is different. *Fautographique* involved amateurs in a tongue-in-cheek entertainment, an inversion of values that gave photography's rejects their brief moment of glory. In contrast, Chéroux has no interest in carnival with its temporary licensing of disorder. His aim is more ambitious. Subtitled *Petite histoire de l'erreur photographique* (that is, *Little history of the photographic mistake or slip*), *Fautographie* seeks to treat blunder as a "cognitive tool", based on the assumption that "it is in its shadows—its failures, accidents and slips—that photography is most revealing about itself and presents itself the best for analysis".

The book includes material from the nineteenth century to date, but the core is two chapters on the historic avant-gardes of the first half of the twentieth century. One chapter deals with New Photography in Germany, concentrating on Werner Gräff and László Moholy-Nagy; the other is about Man Ray and Surrealism. In both chapters, Chéroux argues that photographic innovation occurred through creative engagement with the errors associated with the amateur novice.

He values highly the book *Es kommt der neue Fotograf!* (*Here comes the New Photographer!*) by Werner Gräff. Published to coincide with the German Werkbund's international exhibition Film und Foto, Stuttgart, 1929, it targeted the amateur photographers who were already curious enough about what was called the New Photography to visit FiFo. Gräff's contents involve extended debate with the artistic advice found in the usual manuals for amateurs. The first chapter opens with a two page spread of four landscape photographs, a familiar theme for the amateur photographer on vacation. On the left hand page are two photographs composed according to the two thirds/one third formula known as the "golden mean", and on the right hand page are two counter examples which ignore the rule. In one 'bad' photograph, the horizon divides the scene into two equal halves; in the other 'bad' example, the

horizon is totally absent since the photograph was taken from an aerial perspective. Gräff defies the reader to dismiss his counter examples as failures. In another chapter, Gräff uses image-text juxtaposition to challenge received wisdom about photographic portraiture, another genre popular with amateurs. On each page, a textbook gobbet is reproduced. "Not too much from below..."; "A pretty face is spoilt by deep shadow"; "The hands must have a more subdued lighting than the face..."; "Beware of hands or legs stretched out towards the camera". And for every cliché, Gräff provides a matching image that demonstrates how so-called "laws" can be successfully ignored. For Chéroux, Gräff's scipto-visual polemic is exemplary, a "genuine counter manual, a wrong footed primer, the bible of photographic subversion".

He writes about Moholy in the same vein. Purple passages analyse Moholy's fascination with the productive error, summed up in a quotation from *Vision in Motion*, first published in 1946:

> The enemy of photography is the convention, the fixed rules of the 'how-to-do'. The salvation of photography comes from the experiment. The experimenter has no preconceived ideas about photography. He does not believe that photography is only as it is known today, the exact repetition and rendering of the customary vision. He does not think that the photographic mistakes should be avoided since they are usually 'mistakes' only from the routine angle of the historic development. He dares to call 'photography' all the results which can be achieved with photographic means with camera or without; all the reaction of the photo sensitive media to chemicals, to light, heat, cold, pressure, etc..

Chéroux takes as his main practical example Moholy's relentless attempts to include, rather than exclude, his own shadow in his photographs. Here failure becomes success if the 'mistake' draws attention to a technology that depends on light and shade, and to a person operating the technology, thereby challenging the transparent reputation of the medium. For Chéroux, then, one of Moholy's great achievements was to realise that error can be "an extraordinary cognitive tool, laying bare the fundamental principles of photography".

In the complementary chapter on Surrealist photography, Chéroux foregrounds another 'mistake' that amateurs are still warned about—reflections in shop windows. The theme was popular with a photographic hero of the Surrealists, Eugène Atget; featured prominently in Surrealist writing, most notably Louis Aragon's *Paris Peasant*; and was an obsession of Surrealism's own self-confessed 'fautographe',

Man Ray. Chéroux offers a number of reasons for Surrealism's love affair with such images. One: they transgressed established rules about good photography. Two: they generated problems of perception, registering the sensory confusion of the urban experience. Three: they blurred the usual distinctions between interior and exterior. Four: such images exemplified the fascination with the collages or montages of everyday life that could be discovered in the city by the suitably attuned Surrealist rambler.

Chéroux's concluding generalisation is that New Photographers used error to help them discover the real potential of photography as a medium, whereas Surrealists used it to investigate the secrets and surprises of urban reality. The agendas were different, but in both cases it was assumed that advances depended on the courting of error.

Chéroux has some suggestive comments to make about error as a 'cognitive tool' now, but offers nothing comparable to his highly suggestive, detailed analyses of the historic avant-gardes. Yet the latter are of more than academic interest, providing a yardstick to evaluate current preoccupations with getting it wrong.

Take another French publication: *Manuel de la Photo Ratée* (*Manual of Botched Photography*), written by a recent fine art graduate called Thomas Lélu, and published by Al Dante in 2002. On the title page, the author announces: "For the attention of those who use portable or throwaway cameras, but also of professionals, because it isn't that easy to create botched photos". The guide has two sections: one is about the camera and deals with themes like blur, lighting and framing; the other is about the subject and tackles actions, 'sorry specimens' and portraits. On each page there is an anonymous visual example, an identification of the classic mistake, and a commentary. Although it is designed like a conventional how-to-do-it guide for the keen amateur, in this case the author explains how-to-do-what-you-are-not-supposed-to-do. Overall, the manual is an enjoyable celebration of the 'artistic' mistake, committed to convincing readers that their unhappy snaps should be considered happy. Yet, it must be said, although the book is permeated with a pleasing libertarian sentiment, it has none of the serious theoretical underpinning that makes Gräff's counter manual of the late 1920s such an astonishing item.

Manuel de la Photo Ratée is not an isolated phenomenon. Rather it should be viewed as part of the enthusiasm of many contemporary artists and photographers for the 'look' of amateur photography: Billingham, Day, Strba, Tillmans, Waplington, for example. The broader socio-political context for this turn is the apparent exhaustion of all revolutionary currents, including the ambitious attempts of the various avant-gardes of the twentieth century to merge art, politics and everyday life. (Peter Wollen has argued plausibly that the avant-garde was born in Paris when Marinetti published his *Futurist Manifesto* on the front page of *Le Monde* in 1909, and ended in 1972 when Debord dissolved the Situationist International, also in Paris.) In such a situation, many claim, the only possibility for radical experiment is within the relative intimacy of social groups like the family, networks of friends, or sub-cultures, often based on sexual identity. "History has shattered into a thousand singular, individualised and autarkic micro-narratives" notes French critic Dominique Baqué in an article that complains about the corresponding art—photography in an amateur style, errors and all. ("The Age of Suspicion", *Art Press* 273, November 2001.) Needless to say, error now is rarely the 'cognitive tool' of the historic avant-gardes. Rather, it becomes a badge to be worn conspicuously, a guarantee of authenticity.

Not always, though. More challenging engagements with incompetence are also to be found that aim to match the ambitions of a Moholy or Man Ray. For example, *End of an Age*, 1999, by Paul Graham. The book includes an interview in which he describes his youth portraits as "very unprofessional", embracing "mistakes" like blur, colour casts, camera shake, red-eye and bad-flash technique. "Many of these pictures would make a professional photographer shudder", he willingly concedes, yet there is method in the mistake making. Take the red-eye portraits:

They were actually the starting point, my opening idea back in 1995. I wanted to use this fire of life, to deliberately capture it. I'd found a particular camera combination which meant that more than half of my photos would be with red eyes. So I could, virtually at will, get this kind of picture, and I wanted to use the kind of hunger it suggests. But I also love the fact that it is considered a mistake and that the camera manufacturers have introduced special buttons to get rid of it. As the book developed my ideas grew far beyond that starting point, but I decided to use them like bookends, opening and closing chapters, to give it that hunger, that seeking quality.

Suggestively, Graham describes *End of an Age* as "anti-Photoshop". Photoshop's filters for creating the flawless photograph are considered symptomatic of wide ranging contemporary obsessions with an impossible perfection—"everyday flawlessness". In contrast, he wants to embrace imperfection and to use it for his own purposes. *End of an Age* is a stunning flaw show.

F

Jo Spence, *The Family Album 1939 to 1979*, 1979.

Family Album

Beyond the Family Album is a touring exhibition by Jo Spence (1934–1992). It was originally part of an Arts Council survey called Three Perspectives on Photography (The Hayward Gallery, London, 1979) and was recently shown at Belfast Exposed. The work is over 25 years old, but remains resonant. My primer identifies themes that were important for Jo when she made this exhibition, presented as a series of loosely connected fragments.

Amateur

The amateur and the professional are often considered opposites. One works for love; the other for money. One can be untroubled by incompetence; the other claims competence by definition and can use the adjective amateurish as a term of denigration. Jo rejected these 'commonsense' distinctions. She was a professional—in the 1960s and early 1970s she made her living as a high street photographer in Hampstead, specialising in portraiture and weddings—but she came to value the amateur highly. Indeed, when asked about political photography in the early 1980s, she replied that her main interest was "a radicalised type of amateurism". (*Camerawork*, no. 29, Winter 1983/1984.)

Amateurs were the target audience of her first book —*Photography*. Co-authored with Richard Greenhill and Margaret Murray, it was published in 1977 as part of a series called *Macdonald Guidelines* that aimed to offer short, lively introductions to a wide range of topics from astrology to yoga. It is very different from conventional photographic manuals for the novice. These tend to be by and for men, usually proffering a heady mix of technical information and the wisdom distilled from a lifetime in the business. In contrast, the authors of *Photography* seek to avoid gender bias, keep the technical sections to a minimum, and play down their own professional track records. "Why photography?" is the opening chapter and the first paragraph begins disarmingly:

> Much mystique surrounds the techniques and professional practices of photography, whereas in reality the basic craftsmanship involved is quite easy to learn. What many people find difficult is knowing what they want to say and discovering a means of saying it through pictures.

What ensues in less than a 100 pages is a clear and concise exposition of conventional uses of photography and some suggestions for radical alternatives.

Significantly, there is a section called "Snaps" which takes family photography seriously. There are no hints on how to raise the technical standards of the family album. Rather, the authors encourage reflection on the meaning of such albums, for "only

David Evans, *Jo Spence, Beyond the Family Album: a primer*, 2005.

recently have people begun to realise the value of snapshots and family albums as a valuable source of personal and historical information."

Art

Not "Is it art?"Rather, "Who is it for?" These questions were the core of the statement of aims of the Half Moon Photography Workshop, an organisation committed to using photography for social change (*Camerawork*, no. 1, February 1976). Set up in the East End of London in Autumn 1975, it was mainly a gallery, magazine and programme of educational workshops. Jo was a founding member and wrote the lead article for the first issue of the magazine *Camerawork*. Entitled "The Politics of Photography", it elaborates on the Workshop's mission statement, with dismissive remarks about commercial photography and photojournalism and an emphasis on the prospects for radical community photography.

Also in 1976, photographer William Eggleston had his now legendary solo exhibition at the Museum of Modern Art, New York. The accompanying catalogue —*William Eggleston's Guide*—was later to be listed as a book received (*Camerawork*, no. 7, July 1977) but was not reviewed. My point is not that the Half Moon failed to recognise Eggleston as a seminal figure in contemporary art photography, but that the collective was indifferent or hostile to MOMA as 'The Judgement Seat of Photography'. (Christopher Phillips, "The Judgement Seat of Photography", *October* 30, Fall 1982.)

Jo's lack of interest in the agenda of John Szarkowski, chief photographic curator at MOMA, did not preclude a passionate engagement with other aspects of art and photography. In the 1970s, she became very interested in the revolutionary cultures of the early Soviet Union and Weimar Germany, particularly those aspects that dealt with the potential of new media like cinema and illustrated press to radically transform the everyday lives of working people. (For her and many others, the film theory journal *Screen* was essential reading for materials on the historic avant-gardes of Central and Eastern Europe.) Above all, the German photomontage artist John Heartfield became a constant source of inspiration for Jo, especially after she saw an exhibition of his work at the ICA, London, in the late 1970s. (Eckhard Siepmann's catalogue was the subject of an appreciative essay in *Creative Camera* 305, August/September 1990.) Yet she was not uncritical of Heartfield and always made a sharp distinction between the useful and the useless. She had little time for the celebratory pro-Soviet stuff, but she was fascinated by the anti-Fascist photomontages of the 1930s that used irony, vulgarity and played with contradiction.

In the 1970s, she was also very curious about contemporary artists who resisted the idea of art as a collection of visual artefacts to be collected, displayed and contemplated, and who adopted radical alternatives like writing or ephemeral performance. For such artists —for convenience, let's call them Conceptualists—one of the few concession to visual representation involved the use of the camera as an informal recording instrument, considered permissible because of photography's marginality in the museum, and its pervasiveness in everyday culture. Take Victor Burgin, another contributor to *Three Perspectives*. Trained in fine art at The Royal College of Art and Yale, his formation was quite different from that of Jo Spence, former high street photographer. But she was quick to identify mutual concerns—the visual rhetoric of the advertisement, for instance—and asked him to write an article for *Camerawork*. (Victor Burgin, "Art, Commonsense and Photography", *Camerawork*, no. 3, July 1976.) Subsequently their paths were to cross many times, not always without friction.

Victor Burgin and John Heartfield: for me, the two artists who gave Jo the confidence to find her own way of working with photographic documents that did not end up looking like mainstream documentary photography.

Education

One the inside cover of *Photography*, Jo is described as being "particularly interested in the development of photography as a critical tool in education". Along with Terry Dennett, she was also a leading force behind the educational activities of the Half Moon Photography Workshop whose statement of aims included a commitment to "initiate projects and promote interests in the use of photography as an educational tool, particularly in the field of play, literacy and schooling". (*Camerawork*, no. 1, February 1976.) A detailed exposition of their work in this area became the article "Photography, Ideology and Education" (*Screen Education* 21, Winter 1976/1977). Note that this article and the Macdonald book both suggest projects on identity scrapbooks and visual life-lines. For example, one suggestion in *Photography* starts:

> Sort out all the pictures in which you feature. Then, arrange them in date order (starting with the earliest on the left-hand side) in a long line across the room. In this way you can plot out a visual progression of the physical changes, fashions, styles, etc., through which you have passed.

There is an obvious link between the above brief and *Beyond the Family Album*.

Jo often described herself as an educational photographer and once explained: "The term comes straight out of Brecht. My understanding of Brecht's

work is that it could be educational and entertaining at the same time..." (John Roberts, "Interview with Jo Spence", *Selected Errors: Writings on Art and Politics 1981–90*, 1992). As I cite her words, an image goes through my mind of Jo arriving at an adult evening class in the early 1980s with her camera lens protected by a condom—discreet advice for male photographers, perhaps. Jo was a joker. She loved disguises, mockery, permanent carnival.

She was also an educationalist in the way she was always keen to take on new roles and to encourage others to do the same. For instance, the journal *Camerawork* was initially an opportunity for practising photographers to put pen to paper, and *Photography* was co-produced by a trio of photographers who wrote the text and supplied most of the images. But a more adventurous example of what I have in mind was the anthology *Photography/Politics: One*, Photography Workshop, 1979. Photography Workshop was basically Terry Dennett and Jo Spence, operating from their small flat above a shop in Islington. In their spare time, the two of them (with help from assistants, including myself) worked as publishers, editors, designers and contributing writers. Note, too, that both were trying their hand for the first time at academic history writing, albeit from a partisan perspective, on interwar Worker Photography in Britain (Dennett) and images of women in World War Two (Spence). Overall, the production of *Photography/Politics: One* was a conscious defiance of traditional divisions of labour, with everyone involved passing on skills and learning new ones. Brecht again, I might add—the Brecht of the *Lehrstücke*, the teaching and learning plays of 1929 and 1930, aimed at revolutionary students and workers, that sought to dispense with traditional notions of professional playwright, professional actors and appreciative audience.

Politics

Jo was a Socialist Feminist. She had sympathies with artists and photographers who tried to directly service political causes: Peter Dunn and Loraine Leeson, for example, who made issue-based posters with the collaboration of campaigning community groups in London's Docklands, or Peter Kennard, well known for his anti-nuclear photomontages for CND. She also had sympathies with figures like Victor Burgin who argued that the representation of politics had to be preceded by research on the politics of representation, to use an overused formulation of the 1970s one more time. But her heart was in something else:

> Within all households, forms of domestic warfare are continually in progress, and although we live this daily power struggle, it is censored, displaced,

put off-bounds, transformed into icons of ritualised harmony within family photography.... A political practice (with a small 'p') would seek to find ways to question this so that we could discover for ourselves the multiple discourses that so articulately invent and re-invent daily life for us (from the familiar television set to school reading books.) (Jo Spence, "What is a Political Photograph?", *Camerawork*, no. 29, Winter 1983/1984.)

Work

Jo defied conventional notions of work. She made no distinction between finding a useful photograph and taking one. She also wrote about photographs and talked about them, amongst other things. (In my opinion, her interviews were often stunning performances, an underestimated dimension of her creative work that needs to be taken as seriously as the photographs and writings.) She also enjoyed collaborative projects that challenged a modern emphasis on individual achievement. In Three Perspectives, for instance, she pops up twice: first, as herself in the Feminist section; secondly as a member of The Hackney Flashers Collective in the Socialist section. In addition, she was an important catalyst, good at making proposals or setting an example that others could pick up on and develop in their own way. He work is to be continued....

(David Evans was a co-editor of *Photography/Politics: One*, Photography Workshop, 1979). He thanks Terry Dennett for his comments on a first draft.)

Forest

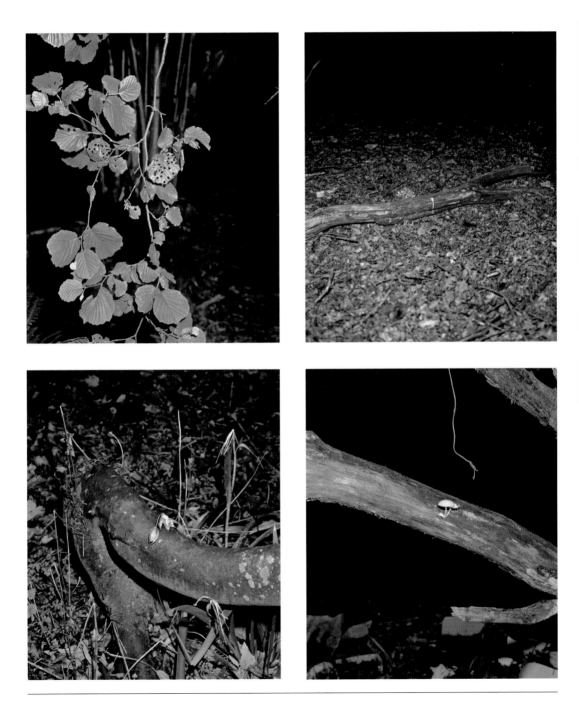

opposite and above/ Tim Edgar, *Rookery*, 2003.

F

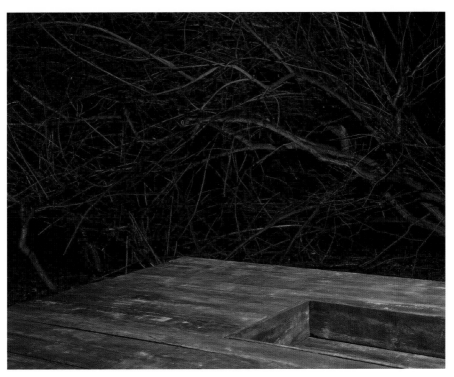

opposite and above/ Bianca Brunner, *Untitled*, 2006.

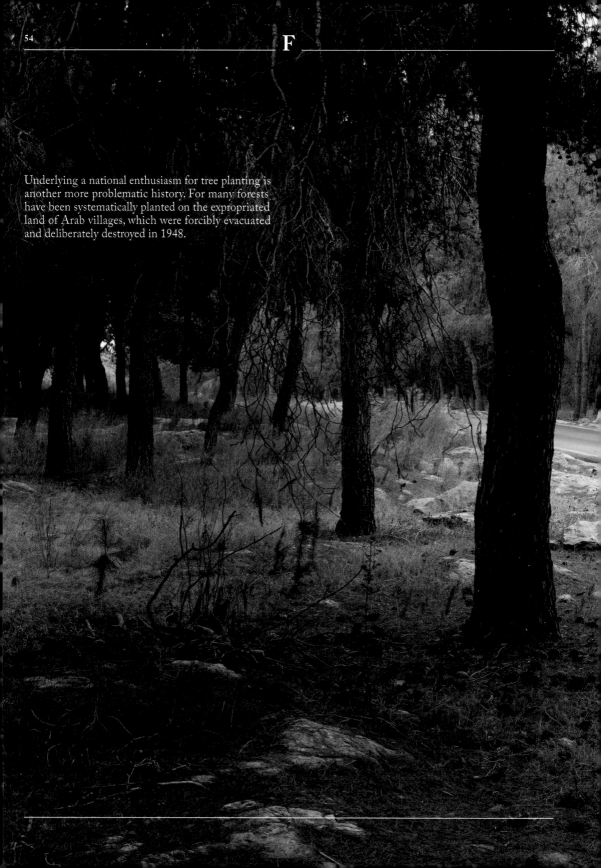

F

Underlying a national enthusiasm for tree planting is another more problematic history. For many forests have been systematically planted on the expropriated land of Arab villages, which were forcibly evacuated and deliberately destroyed in 1948.

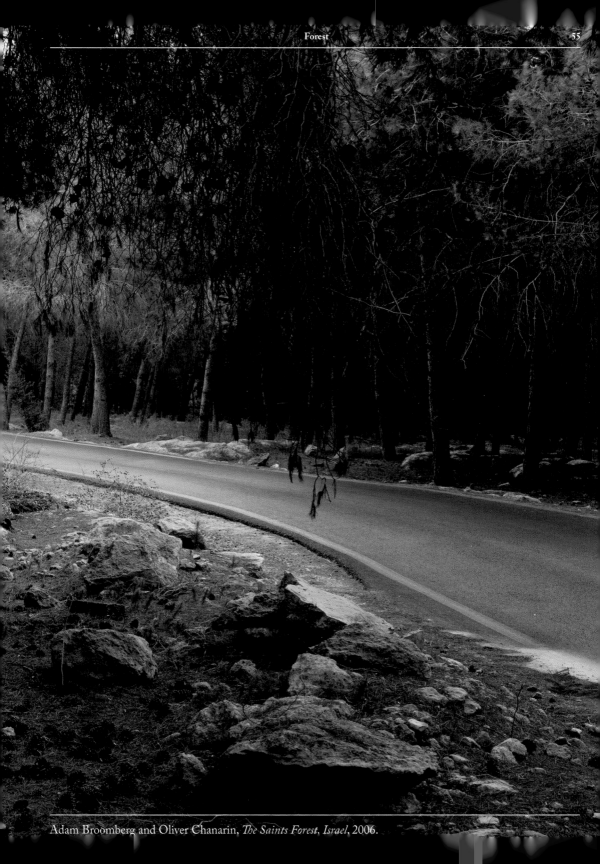

Adam Broomberg and Oliver Chanarin, *The Saints Forest, Israel*, 2006.

Ghost Image

Hervé Guibert (1955–1991) is best-known as a novelist, although an exhibition in 2011 at the Maison Européenne de la Photographie, Paris, confirmed that he was also a photographer and filmmaker of note. In addition, he wrote extensively about photography. From 1977 to 1985 he was the photographic critic for *Le Monde* and most of these writings were collected and published by Gallimard as two volumes in 1999 and 2008, respectively. However, his most significant literary engagement with photography was probably the little book *L'Image fantôme*, Paris, 1981, published in English in 1996 with the title *Ghost Image*.

Roland Barthes published *La chambre claire* (*Camera Lucida*) one year earlier and there are some obvious overlaps. Famously, Barthes discovers the secret of photography in one photograph of his mother that is simply too personal to be reproduced. Guibert goes further and writes a book about photography in which there are no reproductions at all, although the American edition makes a slight compromise, using an Autoportait by the author as a cover image. In the first half of *La chambre claire*, Barthes works his way through a selection of images that have struck him over the years, and in a section of *Ghost Image* called "Favorite Photographs", Guibert writes that he had considered doing something that would have been similar. Instead, though, his book "speaks of photography in negative terms, it speaks only of ghost images, images that have not yet issued, or rather, of latent images, images that are so intimate that they become invisible". He also states that the book is "becoming something of an attempt at biography through photography".

Any remarks by Guibert about biography or autobiography should be taken with a pinch of salt since his specialty was autofiction or fictionalised autobiography. For example, the *L'Homme au chapeau rouge*, Paris, 1992, published in English the following year as *The Man In The Red Hat*, might be treated as a detective story or as an autobiographical account of the author's struggle with HIV. A key part of the book involves the narrator spending time with a Greek painter called Yannis who paints his portrait:

There are events that refuse to be reconstituted in writing. This is the third time I've tried to describe the sittings with Yannis, and over the past several months I've felt compelled to tear up the pages at once. It was a betrayal, a banalisation of the solemnity of the occasion. I had a real mystery to tell, therefore something that cannot be grasped: the flight of the flesh into paint, the progressive bleeding of the soul onto canvas.

Reproduced opposite is a portrait of Guibert in 1990 by one of his close friends—the Spanish artist Miquel Barcelò. A few months later Guibert was to give up the ghost, in his mid-30s. Barcelò is Yannis; Guibert is the narrator; the reproduction is the portrait described above. Or perhaps not.

(Frédérique Poinat is the author of *L'œuvre siamoise: Hervé Guibert et l'expérience photographique*, Paris: L'Harmattan, 2008 in the series *Champs Visuels*.)

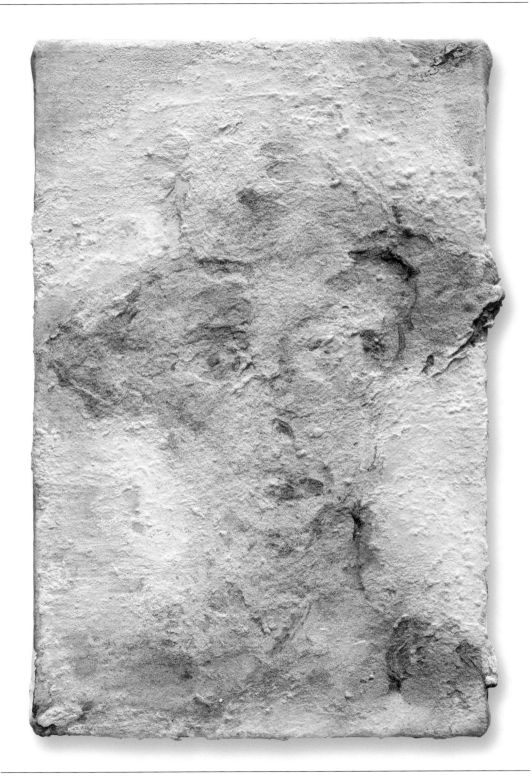

Miquel Barceló, *Belfegor no 4*, 1990.

Human Writes

Human Writes was a performance installation that premiered in Zurich in 2005. It was co-created by William Forsythe, an American choreographer based in Frankfurt, and Kendall Thomas, law professor at Columbia University, New York. Their starting point was the *Universal Declaration of Human Rights*, adopted by the General Assembly of the United Nations in 1948. *Human Writes* focusses on inscription and draws attention to the gap between the ideals of the original declaration and the reality more than 50 years later. Production shots from the original production are by Dominik Mentzos.

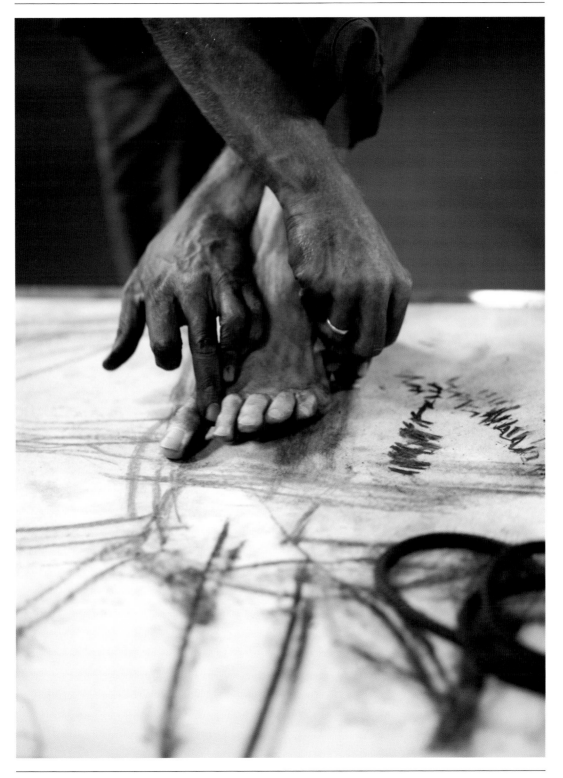

Dominik Mentzos, *Human Writes*, 2005.

H

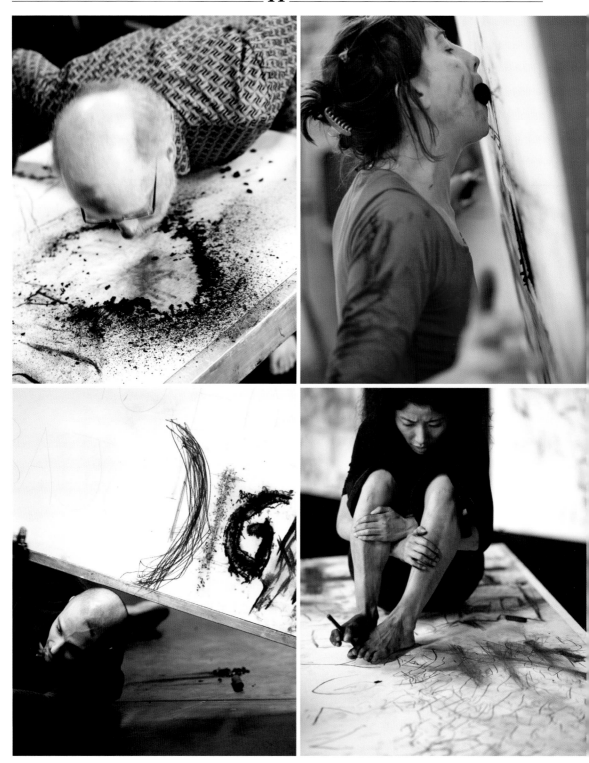

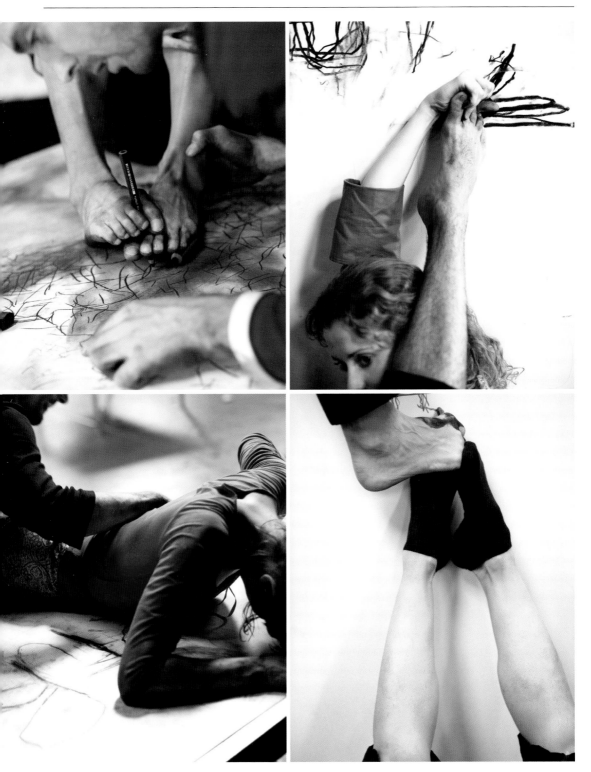

opposite and above/ Dominik Mentzos, *Human Writes*, 2005.

Humve(il)

Humvee
... a kind of meta-camera: a large black box, dark inside,
rolling through the streets of Baghdad.
(Chris Hondros, photographer)

Veil
... the feminine gaze that filters through the veil is
a gaze of a particular kind: concentrated by the tiny
orifice for the eye, this womanly gaze is a little like
the eye of a camera, like the photographic lens that
takes aim at everything.
(Malek Alloula, writer)

Al Gebra, *Humve(il)*, 2008.

Informe

... affirming that the universe resembles nothing and is only formless amounts to saying that the universe is something like a spider or spit.

Simon Cunningham, *Duckrabbit*, 2011. Georges Bataille, *Formless*, 1929.

Jewellery

Brilliant Effects: a Cultural History of Gem Stones and Jewellery, Press, 2009, is a major new work by art historian Marcia Pointon. Published for Yale University's Paul Mellon Center for Studies in British Art, it might appear to be a book for academic specialists. Not so.

 Marcia—some might consider your theme to be no more than a short footnote in the history of luxury. Why do you disagree?

 For economic historians, the seismic shifts of the long eighteenth (the development of cities, the evolution of masculine civic virtues and forms of republicanism, mercantilism, individualism and politeness) manifest themselves in debates about luxury; for them the argument focused on how the benefits of international trade could be prevented from transforming England into a nation of feminised consumers. Their evidence is drawn from polemical tracts and parliamentary debate rather than from any examination of what it meant to individuals to have luxuries and to consume them. For their part, social historians and historians of dress have addressed the history of luxury by seeking to establish the extent and nature of goods imported and purchased (through inventories, probate registers, etc.) and to map changes in fashion through representations whether in fiction, in diaries or in portraiture. Among many scholars there has been a preference for investigating the 'middling sort', the gentry rather than the nobility or the aristocracy. My work breaks new ground in so far as it takes a particular category of luxury material, jewels, and asks not only who had them and how did they get them but how they used them and what they meant in social and personal terms. It is, if you like, a micro history of a type of thing valued by both women and men.

You have chosen an overlooked theme and you seek to tackle it in an innovative way. Could you say something about the types of writing that you challenge and the types that elicit your sympathy?

 I have drawn on many methodologies in my work and, even when I disagree with writers over

their approach I have nonetheless learned from them. I do not feel embarrassed to use the word maverick of myself as a scholar if this means that I do not adhere to a particular formula for asking questions about the past. I have been, and remain, endlessly curious about how to understand the interplay between the empirical (yes, stuff does happen), the materiality of the past whether this means necklaces or paintings in gilt frames, and the ideological shaping role of representation. As someone much inspired by Foucault in the 1980s I am deeply interested in discursivity, in truth effects that are constructed rather than given. I have learned much from those anthropologists and sociologists for whom material evidence is paramount but equally for whom it is never unmediated truth. I am thinking here of Clifford Geertz, Marcel Mauss, James Clifford and others. I am unsympathetic to what I would term protectionist scholarship: arguments in academic journals' letter pages that are self-perpetuating and self-important. I am sometimes exasperated by historians who 'discover' imagery (made vastly easier by the Internet and by research databases like the British Museum's wonderful collections open access site) and who think they have invented the wheel. I am unsympathetic to those who use visual material but do not LOOK at it for its visuality, its aesthetic qualities, its affect, its fictionality and its contextualisation.

Brilliant Effects presents detailed evidence found in archives and museums in a number of countries. Yet the presentation of this evidence is often informed by the ideas of major theorists across several centuries. Could you give an example of how theory has influenced your formulations? Or how your archival activities have undermined or modified a theoretical generalisation?

 This is a tough question. At heart, I guess my work is hermeneutic in character—interpreting and explicating phenomena and groups of phenomena that present themselves to me from the untidy mess that what we call history throws up. Why particular things compel one to question is, of

David Evans, *Brilliant Effects: an interview with Marcia Pointon*, 2011.

course, a mixture of opportunism, expediency and personal intellectual and emotional history. To coin a phrase much spoken in conversation by my friend Paolo Palladino, a historian and philosopher whose work I much admire, I am driven to ask not only what is/was it and why is/was it there but WHAT IS GOING ON? When I began working with the Ruskin archives for the final chapter of my book, the evidence that was emerging brought together minerals with published and unpublished writings, visual representations, human bodies, and sundry materials such as inscribed books and even models made of pastry. In turning to psychoanalytic theory at this point (and in particular to theories of lack, introjection, and displacement) I was not seeking a key to Ruskin's personality but finding a way of explaining how personal and public practices of collecting, teaching, and gifting might be explained as an historical phenomenon in an age when minerals posed seriously unsettling questions to educated people.

"What has become known as 'bling' triumphs, it could be argued, in proportion to the ever greater virtualisation of money." Or "In times of crisis, jewellery as capital comes into its own...." Aphorisms, anecdotes and observations about the present are continuously encountered in a book that is ostensibly concentrating on eighteenth century England. Why?

There is no 'then' detached from 'now'. We live in our pasts as well as in our presents which are all the time becoming our pasts. That sounds rather sententious but I will also say that my sudden chronological disjunctures are also tactical and deliberate. I want to startle my readers, make them sit up and notice. There is a further reason and that is my analogising method: things are familiar and appear normative so if we are to interrogate them we have to jolt them out of their naturalised context.

Appropriately, *Brilliant Effects* is a beautiful object. Could you say something about how it was designed?

Yale University Press in London is, I think it's true to say, at the moment of writing one of the few publishers of visual culture that involves its authors in the design process to this degree. This is the second 'big' book I have done with YUP and since 1992 the advent of digitisation has made the process both easier and more difficult. Easier because you don't have literally to paste up but more difficult because the digital images supplied by galleries and agencies often do not permit the very detailed close up that the old transparencies allowed. My editor, Gillian Malpass, and I went through every image and decided roughly what dimensions they should be and which would be given additional details, what we would have for the outside cover, the frontispieces to each chapter, etc.. When the first set of page proofs arrived we had another discussion and rearranged things to better support the arguments of the text. Finally, a few more changes were made at the second lot of page proofs. The quality of the images required heavy paper which makes the book more difficult to handle than I would have wished (not good for reading in bed) but I feel very fortunate to have been able to work with Gillian who is both editor and designer and to have had the support of the Mellon Foundation which made possible the book's 371 plates.

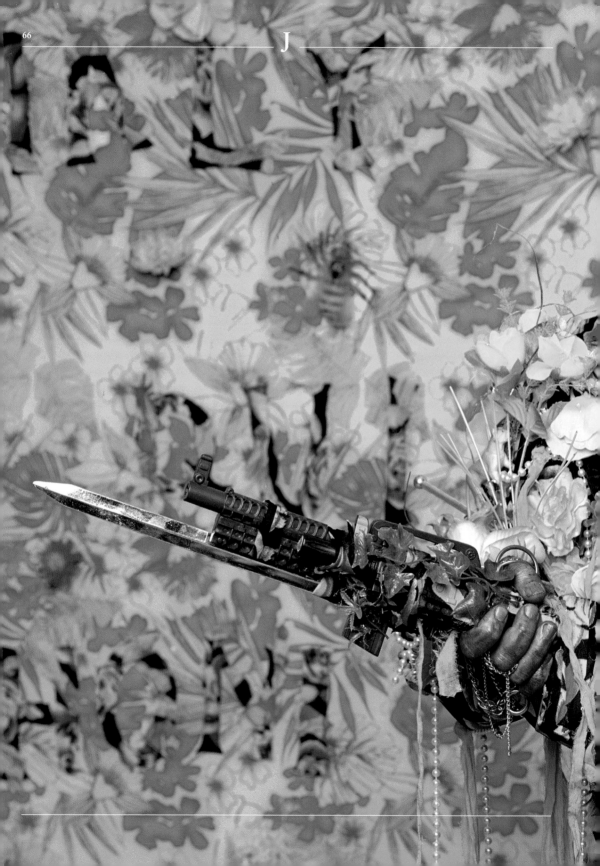

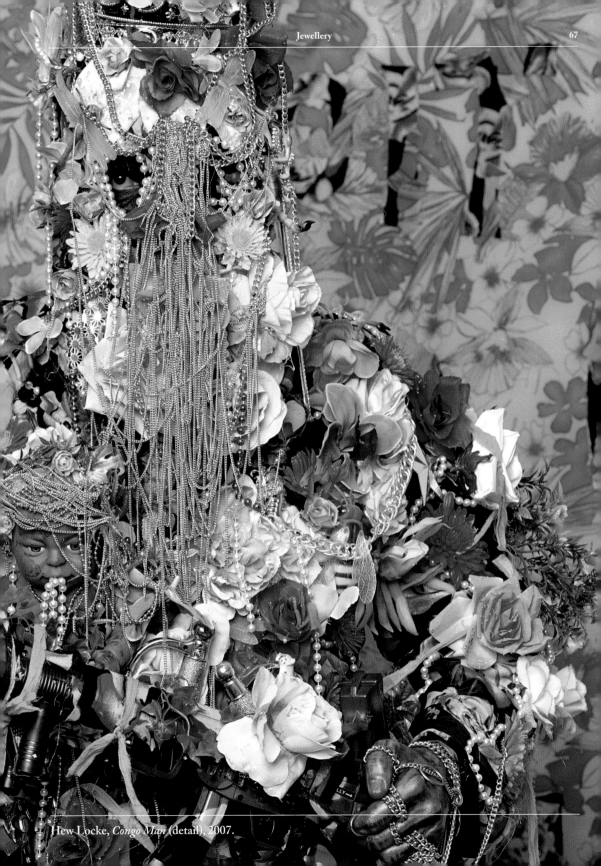

Hew Locke, *Congo Man* (detail), 2007.

Kanak

1920s Hollywood and mid-nineteenth century New Caledonia confront each other on the page. If the top image represents heaven on earth, then the bottom one is hell, the place where the Third Republic sought to contain what it considered the ultimate savages beyond civilised redemption. However, both photographs show groups in a state of undress, involved in comparable forms of drill. They do not appear all that different. Indeed, they are made for each other, the montage implies. To emphasise how the Hollywood dancers resemble the Kanak schoolboys implicates heaven in hell. To emphasise how the Kanaks resemble the actresses implicates hell in heaven. The end result is a dialogue that starts to undermine the supposed barriers between savagery and civilisation.

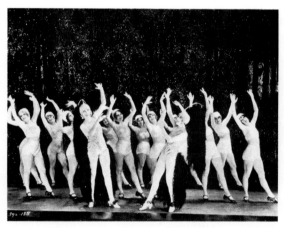

Bessie Love dans le film parlant " Broadway Melody "
qui passera incessamment au Madeleine-Cinéma.

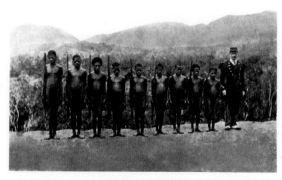

Enfants de l'École de Bacouya, Bourail.
(Albums de photographies de E. Robin, 1869-1871. — Musée d'ethnographie du Trocadéro.)

Montage, *Documents* 4, September 1929, preceding the article "Civilisation" by Michel Leiris.

David Evans, *Kanak*, 2011.

Labour

Walker Evans is rightly celebrated for his definitive images of 1930s America, made in what he enigmatically referred to as the "documentary style". His early ambitions were literary and his lesser-known work for *Fortune* (1945–1965) shows his unique and subversive way of combining words and images. Here is a double-spread of 11 photographs which at first glance looks like a set of serial portraits of anonymous workers taken surreptitiously, perhaps as they leave or enter their place of work. But there are many details that complicate and even contradict this. A crucial paragraph of text makes no reference to the end of a working shift while only three of the subjects are wearing clothes associated explicitly with labour. The piece is subtitled "On a Saturday Afternoon in downtown Detroit", suggesting this may not be a day of work at all, even if this is one of America's foremost industrial cities. These may well be workers but they are not working here. The text occupies a space the size of one of the portraits, as if word and image were of a piece but once read it is clear the purpose is to disrupt the expectations we might have. We are reminded there is no classifiable physiognomy here. Labourers cannot be stereotyped, neither in appearance nor disposition, nor dress: "His features tend now toward the peasant and now the patrician. His hat is sometimes a hat, and sometimes he has molded it into a sort of defiant gesture." These

photographs offer no sure measure. "When editorialists lump them as 'labour' these labourers can no doubt laugh that one off." It is an obvious point but easily forgotten: a person is not anonymous in and of themselves, only to, or for, an other. Looking again at the photos we see they are not entirely serial.

In the first image, a man in overalls seems to look directly at the photographer. The brim of his hat overshadows his eyes, giving the impression he notes the presence of the photographer while keeping something of himself hidden. He stalls the ethnographic fantasy of invisibility, of recording and classifying unsuspecting specimens. Placed top left in the grid the 'portrait' helps to suggest that the shots that follow should not be taken too readily at face value. The final image shows a man and a woman together as a couple in the same frame, complicating any separation 'labour relations' and 'sexual relations'. Perhaps "Labor Anonymous"'is an ironic title, suspicious of the assumptions of mainstream editorialists and readers. (His feature appeared in an issue glorifying "Labor in U.S. Industry".) All this in the space of a single spread of deceptive simplicity.

It is a rare example of a photographer adopting the conventions of the visual typology only to undermine the authority they usually invoke. Suffice it to say, when the photographs are removed from their layout and reproduced simply as serial portraits taken in the street, their meaning is doomed not just to 'revert to type', but to turn the original intention on its head. Here as so often in his *Fortune* work, Evans wanted more than striking, innovative pictures. He was pursuing that rare thing—a space in a mainstream magazine to test the limits of photographic fact.

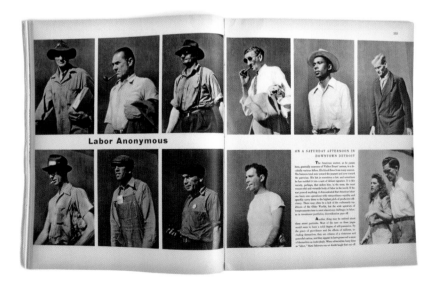

top/ David Campany, *Labour*, 2011.

bottom/ Walker Evans, "Labor Anonymous", *Fortune*, November 1946.

Metaphor

Photography brings us closer
than anything else to the fly,
with its faceted eye and the
broken line of its flight.

Jean Baudrillard, *The Transparency of Evil: Essays on
Extreme Phenomena*, 1993.

Tim Edgar, *Untitled*, 2010.

Monument

The *War Memorial Installation* is a work in which I photographed and re-contextualised existing war memorials and monuments that where build in Serbia between the years 1946–2000 and are located across the entire country. Those monuments have a predominantly modernistic character due to the development that took place in the art of socialist Yugoslavia after the shift in ideology away from the Soviet Union and towards self-determination in the early 1950s. They commemorate local war heroes and massacred civilians and vary in size, shape, meaning and materials.

Some of them are huge and dominate their environments while others are small and modest town and village memorials that are only known to their local communities.

By scaling all the images down to the same size and placing them on the same grey background I attempted to turn them into beautiful, almost abstract objects. Also, by placing them one next to the other— contrary to their solitary position in reality —I detached them from their original meaning.

The meaning that they have today—in a dramatically changed environment—as well as their function as reminders of ideological conflicts and sacrifice is opened to analysis and questioning.

Benjamin Beker, *Statement*, 2008.

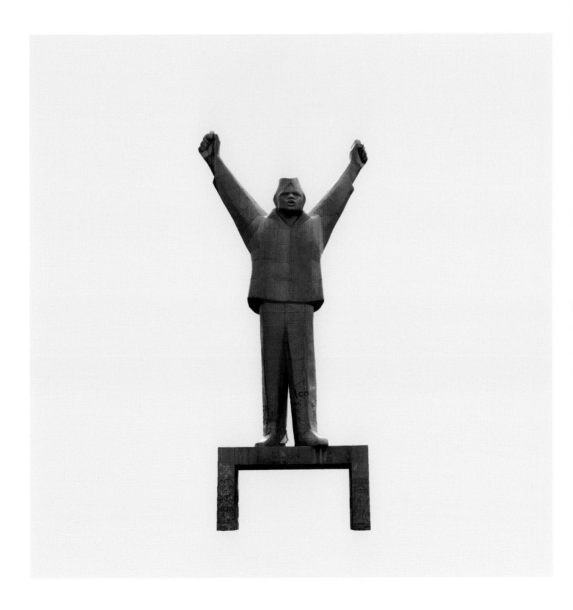

Benjamin Beker, *War Memorial Installation* (detail), 2008.

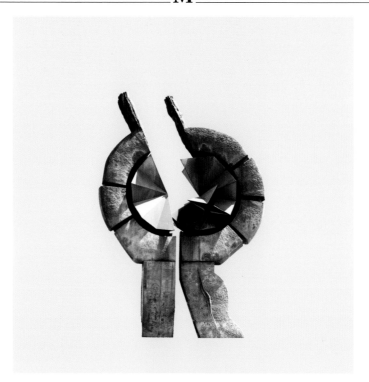

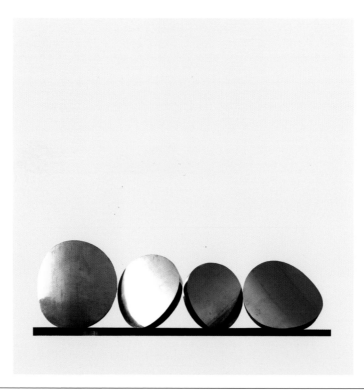

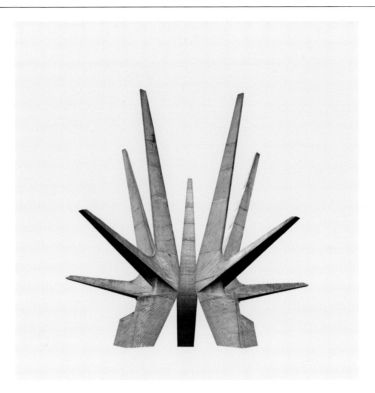

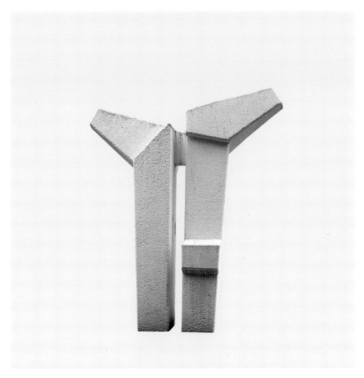

opposite and above/ Benjamin Beker, *War Memorial Installation* (details), 2008.

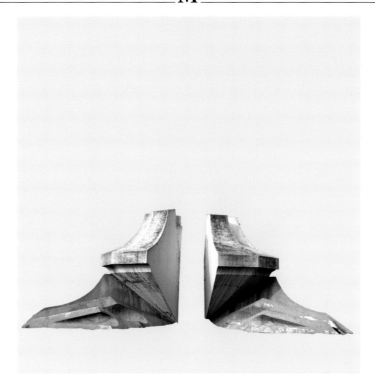

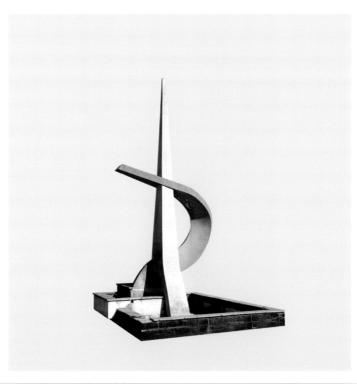

opposite and above/ Benjamin Beker, *War Memorial Installation* (details), 2008.

Mycelium

Still, today, it is usually thought of as reliable, in both its historical and personal forms, a window onto the past or a Mirror reflecting it. So when we discover through new evidence or some other witness that the seemingly concrete representation of an event in Memory is an invention, it comes as a shock. What we present to ourselves is not a reflection of something that happened, but a changing representation without a single source, and this is the Memory-choral that branches out indefinitely and devours its own centre like mycelia do.

Blind Melanaegis (also known as Dionyus, Bromios, Dendrites, Endendros, Agrios, Erikryptos, Eleuthyrios, Oeneus, Lyaeus, Liknites) is stumbling uncertainly through a wood at dusk when he stops by a tall oak. Sensing it next to him, he reaches out an arm to get back his balance, resting a hand on its slippery bark upon which he leaves a trace of the blood that had beaded on his wet palm after an earlier fall. From the magical mixing of blood and perspiration with the thin moss covering the tree trunk springs a cluster of thick-capped, long-stalked Mushrooms, which the exhausted many-faced god feels emerge under his fingers. Ever in search of new experiences, Melanaegis tears them from the tree and instantly devours them.

Fruiting body of the mycelia that lie in the damp under-surface of the earth, Mushrooms have a taxonomic variety that is hard for our textbooks to grasp, threatening to exceed our systems of categorisation and classification. Amorous consumers of moist darkness, they display questionable nutritional value and form 'fairy rings' for reasons still unfathomable to science. Mushrooms are a symbol of not-Enlightenment: they are a dark reminder that the imperial co-ordination that constituted and sustains our cities and canals, our rationalism and knowledge, is not safe, eternal, absolute, or definitive.

Music and Mushrooms: two words next to one another in many dictionaries. Where did he write The *Threepenny Opera*? Now he's buried below the grass at the foot of High Tor. Once the season changes from summer to fall, given sufficient rain, or just the mysterious dampness that's in the earth, Mushrooms grow there, carrying on, I am sure, his business of working with sounds. That we have no ears to hear the Music the spores shot off from basidia make obliges us to busy ourselves microphonically.

Drenched, swaying, looking up at a canopy of leaves: a birth is happening in its wet layers and folds. Dew underfoot; an oval lake in a clearing on the still surface of which is reflected the clearing itself. On the other side is a waterfall beyond the broken contour of an outline chalked onto a factory wall next to a disused canal that leads underground to a zone preceding Memory. Hesitation and confusion in the deeper shade of a damp, gloomy thicket of trees in Oregon, beneath which a massive organism grows unseen in the shape of a skull, which no Mirror can reflect.

Gavin Parkinson, *Mycelium*, 2011.

Dominic Shepherd, *Golden Dawn*, 2010.

Nowhere

Christian Edwardes, *North*, 2008.

N

Christian Edwardes, *West*, 2008.

Christian Edwardes, *East*, 2008.

Christian Edwardes, *South*, 2008.

O

In 1994 the Michael Clark Dance Company premiered
O, inspired by the modern ballet *Apollo*, 1928, originally
choreographed by George Balanchine to music by Igor
Stravinsky. In 2005, *O* was re-staged as *O Stravinsky
Project Part 1* and the photographs of Jake Walters are
from this production.

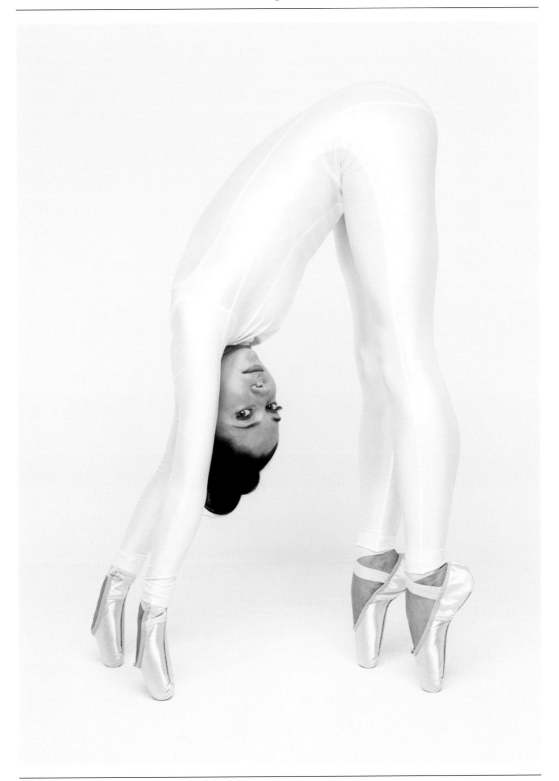

Jake Walters, *O Stravinsky Project Part 1*, 2005.

O

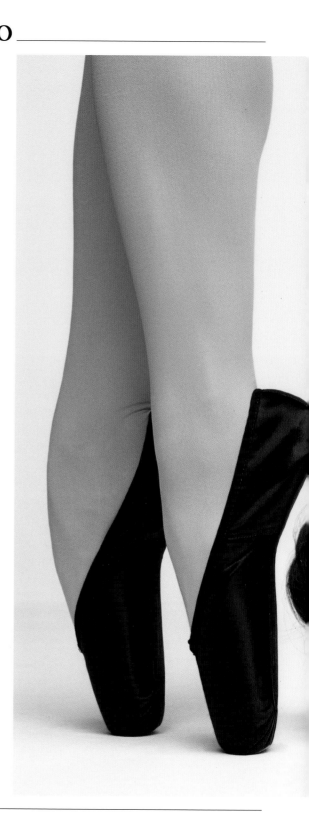

Jake Walters, *O Stravinsky Project Part 1*, 2005.

Ostranenie

The technique of art is to make objects "unfamiliar",
to make forms difficult...

Viktor Shklovsky, *Art as Technique*, 1917.

Simon Cunningham, *Mollymuddle*, 2007.

Overt Research

All photographs are from Overt Research Project, an online database compiled by the Office of Experiments (Steve Rowell and Neal White). The photographs depict test sites for biological warfare, high security telecommunications centres, nuclear power stations, and the like, often shown as discreet presences in a seemingly familiar British landscape.

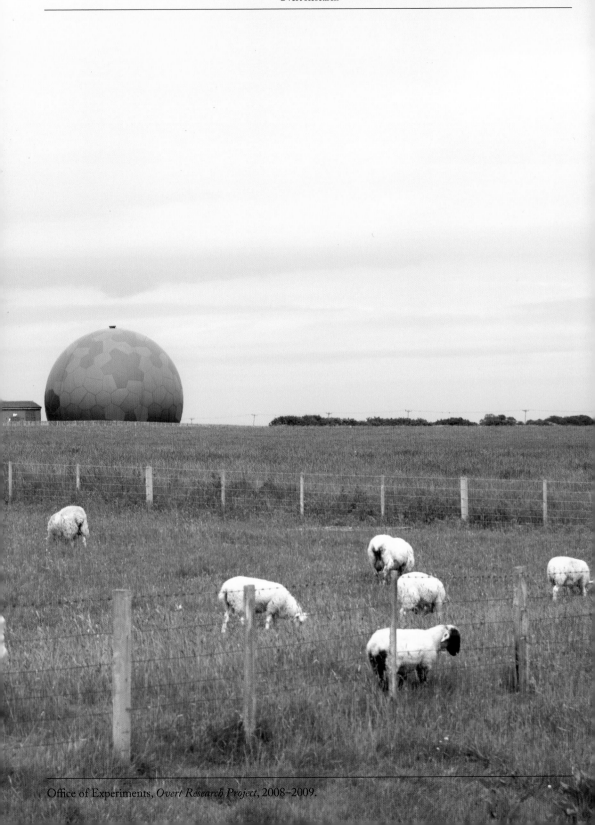

Office of Experiments, *Overt Research Project*, 2008–2009.

O

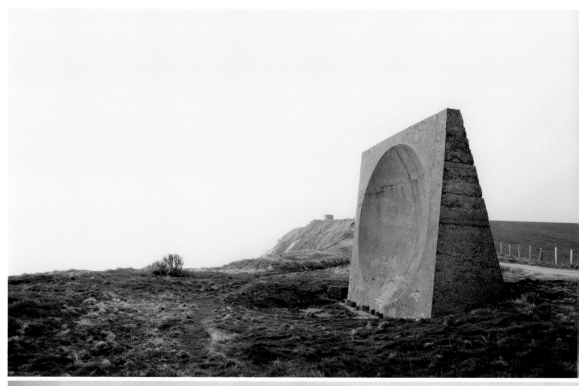

opposite and above/ Office of Experiments, *Overt Research Project*, 2008–2009.

O

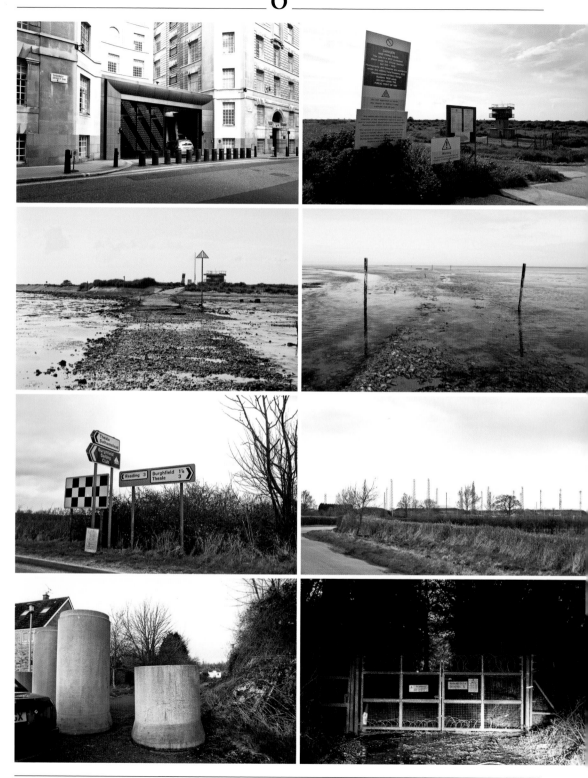

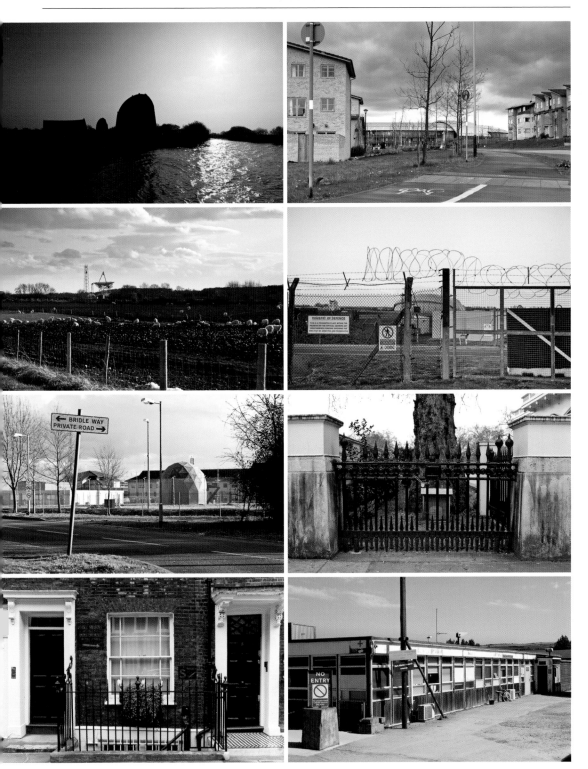

opposite and above/ Office of Experiments, *Overt Research Project*, 2008–2009.

Panegyric

Guy Debord's *Panégyrique 2*, 1997, is mainly a book of photographs, selected and captioned by the author. Published posthumously, it is a visual complement to *Panégyrique 1*, 1989, an autobiographical celebration of Debord's loves, including people, places and alcohol. (Verso brought out an English language edition of the first volume in 1991, and combined the two in a new edition, published in 2004.) The second volume begins:

> The reigning deceptions of the time are on the point of causing us to forget that truth may also be displayed by means of images. An image that has not been deliberately separated from its meaning can add great precision and certainty to knowledge. Nobody has ever cast doubt on this until these last few years.

This doesn't sound like the Debord of legend who supposedly dismisses all images as liars, disingenuous accomplices of spectacular power. Yet the message is clear, unambiguous: he rejects the pervasive contemporary scepticism about the possibility of photographic truth.

One of Debord's favourite forms of picture editing involves the combination of modern photographs and pre-modern quotations to create something like a baroque emblem. The latter was a scripto-visual form of allegory, widespread in the sixteenth and seventeenth centuries. The image was usually composite, containing various elements with allegorical meaning; the text tended to be divided into a title (generally a motto) and a moral comment. Often the individual designs were presented in emblem books whose specific nature is conveyed well in the German word *Lesebilder* (images to be read). Debord, too, chooses photographs that have allegorical potential, and he matches them with quotations that are intended to be instructive, though without the Christian moralising associated with the baroque precedent.

The above remarks help clarify Debord's use of Ed van der Elsken's photograph in *Panégyrique 2*. The photographer is never credited. Neither is *Love on the Left Bank* (Amsterdam and London, 1954), the photo-novel in which the image originally appears. And no mention of Éliane Papaï, the 'extra' in *Love on the Left Bank* who was also Debord's lover. In other words, information is deliberately withheld, preventing a conventional contextualisation of the image. Moreover, Debord radically crops the image, removing the background detail of a night at the Mau Mau Club. Cumulatively, these tactics facilitate the transformation of the photograph into an emblematic image: *The Scowl*, perhaps, or *Liberty Misguiding the People*.

Yet the overall meaning of the emblem depends on the addition of a quotation from the eighteenth century memoirist François de Motteville:

> A private person that those who write history will never know, or will never find worthy of mention. Yet it is this private person which makes it known whether we deserve honour or blame.

Debord's fascination with the baroque goes beyond an interest in emblems, it must be stressed. Rather, he sees the baroque as an alternative to the "false eternal present of the spectacle", argues Anselm Jappe. Jappe continues:

> One of the spurs to the baroque sensibility was an acute awareness of human fragility with respect to time. Debord for his part gave the Situationist project a kind of existential underpinning: the acceptance of the passage of time as opposed to traditional art's reassuring fixation of time and embrace of the eternal.

An acceptance of history, then, combined with a rejection of conventional approaches to historical understanding, like the focus on great men or the deployment of simplistic teleologies. There is no forward march of History in the name of Liberty, Proletarian Emancipation or anything else. Rather, there are merely exemplary moments, necessarily transient, when the presumptions of the ruling order are challenged. For Debord, such a moment occurs in Paris in the early 1950s, when he and his companions start to cause trouble. That moment is the theme of this photo emblem.

The face of Garbo is an Idea, that of Hepburn, an Event. But the face of Éliane Papaï is a Situation.

David Evans, *Éliane: A Situationist Emblem*, 2004. Ed van der Elsken, *Love on the Left Bank*, 1954.

Ed van der Elsken, *Love on the Left Bank* (detail), 1954.

Photography

Limited Edition
George Bush was accused yesterday of exploiting
September 11 for political gain after the Republican
Party began selling a picture showing him calling
Dick Cheney, the vice-president, from Air Force
One hours after the disaster. The photo is part of a
triptych showing the president in heroic mode....

No Pictures
The reclusive Mullah, who is known by his followers
as the "Commander of the Faithful", rarely ventures
from Kandahar and is reported to have only ever met
two non-Muslims. He refuses to allow himself to be
photographed or filmed.

The Camera That Exploded
Mr Massoud was murdered, apparently, by two men
posing as Western cameramen. The camera that he
thought would convey his message to the world blew up
in his face. According to some reports, the murder was
arranged by Osama bin Laden as a gift to the Taliban.

Al Gebra, *The Camera That Exploded and other minor
détournements*, 2006.

Quotation

1/ Photography is the possibility of a reproduction that masks the context. The Marxist Sternberg, for whom you surely share my admiration, explains that from the (carefully taken) photograph of a Ford factory no opinion about this factory can be deduced. (Brecht, 1930)

2/ The situation is complicated by the fact that less than ever does the mere reflection of reality reveal anything about reality. A photograph of the Krupp works or the AEG tells us next to nothing about these institutions. Actual reality has slipped into the functional. The reification of human relations—the factory, say—means that they are no longer explicit. So something must in fact be *built up*, something artificial, posed. (Brecht, 1930)

3/ As Brecht says: 'The situation is complicated by the fact that less than ever does the mere reflection of reality reveal anything about reality. A photograph of the Krupp works or the AEG tells us next to nothing about these institutions. Actual reality has slipped into the functional. The reification of human relations—the factory, say—means that they are no longer explicit. So something must in fact be *built up*, something artificial, posed.' We must credit the Surrealists with having trained the pioneers of such photographic construction. A further stage in this contest between creative and constructive photography is typified by Russian film. It is not too much to say that the great achievements of the Russian directors were possible only in a country where photography sets out not to charm or persuade, but to experiment and instruct. (Benjamin, 1931)

4/ As Brecht points out, a photograph of the Krupp works reveals virtually nothing about that organisation. In contrast to the amorous relation, which is based on how something looks, understanding is based on how it functions. And functioning takes place in time, and must be explained in time. Only that which narrates can make us understand. (Sontag, 1977)

5/ The situation is complicated by the fact that less than ever does the mere reflection of reality reveal anything about reality. A photograph of the Krupp works or the AEG tells us next to nothing about these institutions. Actual reality has slipped into the functional. The reification of human relations—the factory, say—

means that they are no longer explicit. So something must in fact be *built up*, something artificial, posed.

These remarks by Brecht were quoted nearly 50 years ago by Walter Benjamin in his article "A Short History of Photography". In the intervening years considerable attention has been paid to the mechanics of signification, work of great relevance to those concerned to construct meanings from appearances. However, and leaving aside film, the influence of such theory within art has so far been confined to a very few of those manifestations which have attracted the journalistic tag 'conceptual'. (Burgin, 1982)

6/ Conventionally, montage tends to be understood as an opposition to the straight photograph. Bertolt Brecht's famously political call in the 1920s for a practice of image construction is often cited as resistance to photographic fact: "A photograph of the Krupp works or the AEG tells us nothing about these institutions. Actual reality has slipped into the functional. The reification of human relations—the factory, say—means that they are no longer explicit. So something must in fact be *built up*, something artificial, something posed." This is usually seen as an explicit argument for photomontage, anti-realist staging, or the use of text to refunction the image. But in number and sequence images can be made to modify and modulate each other in a critical and reflexive manner close to Brecht's demand for the '*built up*'. Accumulation, repetition, the series and the sequence are certainly less assertive than overt juxtaposition or artifice. Nevertheless, there is an important element of montage here. (Campany, 2003)

7/ Tillmans has said that in photographing gold ingots he indicates something meaningful about money and value. An old remark by Bertolt Brecht is useful here: a photograph of a factory tells you nothing about the relations between the people inside it. The title of his Tate show and book—*If One Thing Matters, Everything Matters*—gives the game away, as well as reflecting the recent art-world prejudice for the straightforward depiction of the 'real'. What is really being granted here are various naturalistic glimpses of objects and people. Access to the real demands a higher price—in thought, knowledge, and the building of structures, and in the realisation that some things do matter more than others. (Stallabrass, 2004)

David Evans, *As Brecht Says...*, 2011.

R

Red House

Adam Broomberg and Oliver Chanarin have photographed marks and drawings made on the walls of a fading pink building now known as the Red House. Situated on the slope of a hill in the town of Sulaymaniyah in Kurdish northern Iraq, it was originally the headquarters of Saddam's Ba'athist party. It was also a place of incarceration, torture and often death for many of the oppressed Kurds for whom the cell walls were the most immediate outlet for expression.

In 1991, prompted by the 'first' Gulf War there was a popular uprising supported by Washington. Iraqi Kurds stormed the Red House, freeing the prisoners, massacring up to 400 Ba'athist officials and members of the security forces. The Ba'athists held out on the rooftop, striking out with mortar shells at the surrounding Kurds. The fighting was particularly bloody and savage. The uprising was eventually quashed but the ravaged Red House was deserted soon after. Falling into dereliction, the site is still thick with evidence. There are the remains of Ba'athist torture cells, lined with wood to muffle all sound. There is evidence of mass rape. There are hooks in the ceilings for securing prisoners. And beneath great concrete slabs, there are mass graves.

These are not the only records to have survived. That last gruesome battle was filmed by video cameraman Abbas Abdul Razza and it is said that the footage has been used in different ways. Ba'athists show it to their loyalists as a warning of what might happen if they don't fight. But for many of them it is a portent of a last bloody stand they feel is coming in the present war. The Kurds have used the film as a tool in the rally for independence from Iraq. Thus the Red House has become a complex and highly contested symbol of Iraq's relation not just with the Kurds but with the current occupying forces in the country.

What is the role of photography in such a situation? Does it still have one? We must accept that as a means of reportage it has been displaced by other media. This eclipse was well under way even in the 1960s. The war in Vietnam, so often thought of as the last 'photographer's war', was perhaps the crossover between still photography and video imaging. In the decades since the place of photography has been redefined, from within and without. Two new paths have emerged for the photographic reportage.

First there is what we might call the nostalgic mode. The now distant 'golden era' of photojournalism looms large in the popular imagination, fuelled by its commodification. It is endlessly repackaged in coffee table books and the news media glossies. At the same time classic photojournalism has been

David Campany, *The Red House*, 2006.

institutionalised in education and photography history, usually as the work of 'heroic individuals' with their 'unique styles'. Rarely is it seen as the product and symptom of a particular moment in the intertwined histories of global economy, warfare and media technology. The result has been an emergence of a new brand of photojournalism that is often keener to quote and imitate its own illustrious history than it is to understand the present.

The second is what I have called elsewhere "Late Photography".[1] Many photographers have responded to the eclipse of their medium by seeing it as a new challenge and a new possibility. They approach the relative primitivism of their means of representation as an advantage, even a virtue. They forego the medium's prior grasp of events, leaving them to video and television. They opt instead to take as their subject the aftermath of those events. In a reversal of Robert Capa's call to get close to the action, proximity is often replaced by distance. Quick reactions give way to slow deliberation. The jittery snapshot is replaced by a cool and sober stare. Lateness replaces timeliness. The event is passed over for its traces. Here reportage takes a forensic turn and in doing so it openly accepts that it will be an insufficient and partial account of things. Most often it lands upon leftovers and signs of damage, both of which are highly photogenic but not easy to decipher. The image becomes a trace of a trace. More to the point this is an overtly allegorical mode of photography. The images present themselves as fragments not wholes, to be read through and against a backdrop of other media representations of warfare and international conflict. Photography becomes a second wave of representation, returning to look again at what was first understood, or misunderstood through television.

Broomberg and Chanarin approach photography as a form of conceptual ethnography. Much of their work has been concerned with the gathering of visual data relating to matters of human behaviour, often in places of political tension. Stylistically, they avoid the overtly creative, opting instead for a pared down, formal approach bordering on neutrality. They have no 'signature style'. For them the world is a set of highly coded surfaces or stages of action. The camera is used to isolate these things, to cut them out for interpretation and reflection. Their camera usually looks at the subject head-on and centre frame, raising the promise of immediacy or 'plain speaking'. Indeed photographically their images tell us quite a lot about what things look like. However the directness of their photographs is offset by the indirect and uncertain status of what it is they select and present to us. For example another of their recent projects looks at first glance like the documentation of a war-torn Palestinian settlement. Closer inspection and supplementary knowledge reveal it to be 'Chicago', the mock-up town built in the desert for the training of Israeli troops. What looks like a classic instance of Late Photography turns out to be something else.

At the Red House many things could have been photographed. Indeed much of it has been, by various parties for various reasons. Broomberg and Chanarin have chosen what at first seems too incidental, too tangential to the history of the building. What are we to make of these marks made by Kurdish prisoners? They are unlikely to be the free and uncensored expression of the oppressed, given their surveillance by guards. Most of the marks are images, not words. Some figurative, some are incomplete and abstract, others are suggestive but elusive sketches. Some of it seems like fantasy imagery, some of it looks like the bored marking of time. We cannot tell what marks were made when and in what order. History presents itself as a palimpsest. If you wish you can sense in these photographs echoes of Brassaï's Surrealist images of scratched graffiti from 1930s Paris or Aaron Siskind's photos from the 1950s of daubs and tears made in homage to abstract expressionist painting. But the context is more pressing and more fraught. The traces recorded by these photographs may relate to past events in the history of the Red House but nothing is settled in Iraq yet. While the photographs are fixed forever, these may not be the last marks made on these walls.

―――

1. See David Campany "Safety in Numbness: some remarks on the problems of Late Photography" in David Green, ed., *Where is the Photograph?*, Brighton: Photoworks/Photoforum, 2003.

opposite and above/ Adam Broomberg and Oliver Chanarin, *The Red House*, 2006.

R

opposite and above/ Adam Broomberg and Oliver Chanarin, *The Red House*, 2006.

Rend

In sacred texts the rending (tearing apart) of clothes often represents the outward expression of inner turmoil. Rending usually bears witness to a relationship to grief, the apocalypse, the rending of the heavens. In *Confronting Images*, Georges Didi-Huberman's argument is that the image is best experienced as rend, that the image is a rend. The image gains its power as rend. But the rend is something we overlook in everyday life. In fact, we are so familiar with the rend that we are often not aware of its existence. Very occasionally, however, something of the violence of the rend is communicated, jolting us into an awareness of its disruptive powers—the rending of the veil, the penetration of truth. But overall, the argument is that the rend reveals the fabric of representation. The image as image can be revealed only by a violation of the image.

Rosetta Brooks, *Rip It Up, Cut It Off, Rend It Asunder*, 2007.

John Stezaker, *Untitled*, 1990.

opposite and above/ John Stezaker, *Untitled*, 1990.

Retort

1/ In *Afflicted Powers*, 2005, you wrote: "The spectacular state is obliged, we are saying, to devise an answer to the defeat of September 11. And it seems it cannot." Well, five years after the publication of your book, it seems that the situation is worse than ever, that the spectacular state has proved unable to devise a real answer in Iraq or Afghanistan. How to explain such impotency?

Well, certainly, it has failed at the level of spectacle. More importantly, on the ground, the US has lost two wars. Which is not at all to say that the peoples of Iraq and Afghanistan are victors, but it does confirm some mainstream strategic opinion that military invasion would end in a "quagmire". Anyone with the slightest grasp of British and Soviet imperial history in Afghanistan could have predicted the debacle. The imperial planners no doubt hope to prevail over twenty-first century resistance to empire— 'people's wars', tribal swarming, non-state actors—with their monopoly of the near-earth atmosphere and new, upgraded delivery of death from the skies. It's unlikely, however, that drones, however 'smart', will be able to counter the low-tech stealth of Buda's wagon and IEDs, and the general refusal of "natives" to respect proxies chosen in Washington.

2/ Does "military neo-liberalism" that you mention need a real victory in order to keep making profits? Could a military defeat still be reckoned a victory?

These wars may be counted as defeats for the state but, from the point of view of particular US corporations, very good for business. Halliburton, Bechtel, Blackwater—these companies are highly successful war profiteers. "Military neo-liberalism", as we called it, was a response to the failure of the WTO to drive through a new round of enclosures with the stroke of a pen at the Seattle ministerial meeting in 1999. The neo-liberal paradise in Iraq, down to the privatisation of all seeds, never came to pass, but despite or because of defeat at one level, there are opportunities for fresh accumulation amid the ruins, though of course ultimately capital has no territorial loyalty. Above all it's what isn't able to flourish in the shambles that

is important, that is to say, any opposition to the capitalist life-world except the answering atavisms of the Right.

3/ You also wrote in *Afflicted Powers*: "For military neo-liberalism is no more than primitive accumulation in (thin) disguise." Is war in Iraq or Afghanistan only a matter of pure profit? Does the progressive privatisation of armed forces announce a new step forward for this model of primitive accumulation?

The state, though ultimately in the service of capital, has its own interests, and where there is a standing army the hounds of war wait crouched for employment. The growth of the mercenary sector conforms to a neo-liberal logic, but it also stems from a contradiction born within modernity's apparatus of mediation, which produces a general thinning of the bonds of human sociability and specifically a tendency to "weak citizenship". Under such conditions it is harder for the state to summon its citizens to defend the *Heimat* half a world away, and the result is a Hessian-style outsourcing of the soldiery. The limits of military neo-liberalism are no doubt pressing on the US state managers, who would prefer that the new enclosures—for example, of the communal farmland and soils of Africa—proceed quietly with the cooperation of local compradors. The new enclosures are mostly

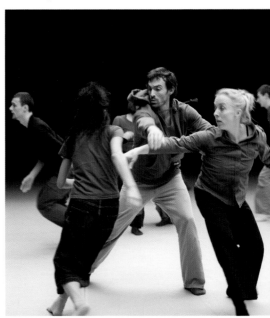

Retort, *Interview with Article XI*, 2009. Dominik Mentzos, *Clouds after Cranach*, 2006.

familiar forms of privatisation, but one can imagine that strategic minerals, inconveniently located beneath indigenous claimants, might find themselves declared "global commons", to be managed by some appropriate body under the eye of the G20. Behind all such arrangements, of course, is state power and its mercenary proxies, standing as guarantor.

4/ What about the announced military retreat in Iraq and Afghanistan? Are Obama's recent declarations on this topic truly credible? If this process were to come to an end, could we expect the spectacular state to be looking out for another target?

Obama's announcement was bogus and everyone knows it, especially the families of the military and the mercenaries, not to mention the Iraqis and Afghans. It was manufactured for domestic markets. As for the next battleground or target in the image wars, who knows? Somewhere in the Islamic zone, one would guess. Apart from Iraq and Afghanistan, the US is currently fighting three other wars—in Pakistan, Yemen and Somalia. Somehow it has to manage these undeclared conflicts in conditions of spectacle, and there is, as we argued in *Afflicted Powers*, the constant danger of a crisis of symbol-management.

5/ Since September 11, anti-terrorism has become a key device to occidental democracies (from Paris to Madrid, Brussels or New York), a pretext for repression. How to cope with this omnipresent propaganda? How would you account for the general lack of criticism regarding this process, notably in the US?

Terror is the health of the state. Modern terrorism's hallmark has been bombardment from the air, the Damoclean threat of mass death aimed at civilians—from Guernica to Gaza. The epithet "terrorist" is projected only onto others— enemies so designated by authorities wherever; as you imply, the term has proliferated to implicate all resistance to capitalist globalisation. Therefore, one must begin by rejecting the presupposition underlying terrorism-talk, and by refusing to engage on the state's rhetorical terrain. As for the general lack of criticism, it is best understood within the US as a compound of fear, indifference, xenophobia, active gagging of critical voices, and perhaps a certain stupefaction induced by the media. Does it need pointing out that Fox TV has an attenuated relationship to reality? A University of Massachusetts study found that the more one watched network news in the United States, the less one knew. The general silence worldwide over repression in the name of anti-terrorism—Sri Lanka and Chechnya come to mind—is partly because

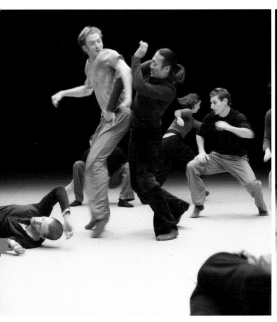

R

military neo-liberalism has normalised open and murderous assaults on civilian populations.

6/ Your book begins with the assessment of the defeat of the so-called left, a defeat that you found was softened by a stream of hope, carried by the demonstrations against the American intervention in Iraq. Seven years later, in hindsight, what is your perception of those demonstrations? Was it the beginning of a real protest movement on the domestic front? Do you think the resistance to the neo-liberal order has grown wider?

We would still insist that the demonstrations of 2003 marked a world-historical moment, when for the first time millions around the world assembled, against the wishes of parties and states, to attempt to stop an imperial war before it began. That said, and although we relished the contempt and insubordination expressed in the placards and slogans, we were already haunted by the limits and insufficiencies of the opposition. The bitter sense of failure to prevent a catastrophe is now conjoined with a palpable sense of political stasis in the face of recent developments, specifically the deepening, double crisis—of capital and of nature. Responses by the global powers exude a zombie-like quality— witness the fiasco of the COP15 climate summit and the nostrums of Obama's dream team. Cap

and trade, pollution credits, biofuel from rotted elephant grass, and other chimaeras peddled by the environmental NGOs—late capitalism's mendicant orders—linger on despite the universal discrediting of neo-liberal ideology, thus perhaps sealing the fate of coastal civilisation.

As for resistance to the neo-liberal order, we would only say that the conditions of its possibility have matured; there is a growing crisis of legitimacy facing modernity's institutions in general. By the same token, there seems to be an exhaustion of the cultural forms and spaces around which the Left has for two centuries organised its opposition. Here in the US, for instance, people go through the motions of a demonstration, but now do so more or less 'ironically'. Perhaps this is not yet the case in France, or in Iran. Consider also the collapse of newspapers, bookshops and antinomian gathering spaces, and their supplanting by the rapture of the virtual and a generalised immersion in the screenworld. We should note too the working out of a profound shift in the field of reception since the emergence of the Internet—on the one hand a splintering and fragmentation of the mass publics of the Fordist era, but at the same time a vast proliferation of worldwide audiences, and a circulation and consumption of images in the global South having a speed and intensity that was unimaginable during,

Dominik Mentzos, *Clouds after Cranach*, 2006.

say, the Vietnam War. By means of this new globalised image-machinery a vanguard is able to feed on the horrors of the *Pax Americana*.

7/ According to you: "Insofar as Hardt and Negri's multitude has constituted itself, thus far, as an enduring political force, its most visible face is that of the Islamic resistance." What about South America and the deep political changes which are currently occurring there? Aren't you giving too much importance to Islamic terrorism to the detriment of other substantial protest movements?

We do not apologise for the book's focus on the phenomenon of al-Qaida, precisely because revolutionary Islam is the most potent—and disastrous—response to a miserable reality which the vanguard aims to exploit, and to which the Left urgently needs to frame an alternative— one that is, as we put it, non-orthodox, non-nostalgic, non-rejectionist, non-apocalyptic. The importance of al-Qaida lies, first, in its seductive power—and visibility is of course crucial to that power—to attract those who reject the life currently on offer in the "planet of slums", and secondly, in revealing how disastrous it is to leave the critique of modernity itself to various mutations of the Right. We certainly have no wish to slight the growing movements of resistance that are diametrically opposed to the vanguard ideal, such as Via Campesina in South America, or Abahlali base Mjondolo, the shack dwellers' movement in South Africa. There are many others, below the radar and counter-spectacular; it is our task to speak with them and not for them.

8/ Your analysis is marked by Situationist theory, particularly the ideas of Debord on the "spectacle". You show how contemporary war is bound up with a globalised regime of images. On this "spectacular battlefield", the leading nations seem to have lost control since September 11: pictures of prisoners subjected to torture at Abu Ghraib, the Israeli attack on the Gaza flotilla, images of civilian murders in Afghanistan, etc.. Is there a current reversal in the war of images? Could new actors like Wikileaks become a real threat to the spectacular State?

The images you speak of have caused plenty of liberal handwringing in the US but little change in policy. Their true impact lies elsewhere; they are, as we have noted, in the bloodstream of revolutionary Islam. We suggested that the modern state, once drawn into the web of modernity's new technics of image production, has found itself vulnerable in novel ways. The events of September 11 are the most dramatic example, but the ubiquity of the phone-camera has led to the phenomenon of 'subveillance'— photography from below, one might say. This is causing headaches for states everywhere. The murder of the bystander Ian Tomlinson, captured on camera at the G20 meeting in London, is a case in point; the official lies were contradicted by iPhone footage taken by a visiting American. Even if some low-level functionary—a GI, a policeman, a prison guard—is thrown under the bus in recompense, subveillance contributes to general mistrust of authority.

You ask about Wikileaks, which is an interesting development that has emerged out of the same contradictions identified in *Afflicted Powers* and immanent in the new apparatus of reproduction. It is indeed a threat to the state and is recognised as such, partly because the baroque and ramified system of official secrecy cannot practically be sealed off; all electronically stored information is potentially just one click away from global dissemination. State-of-the-art firewall technology means anonymity for whistleblowers. Ironically Julian Assange, the founder of Wikileaks, has recently himself broken cover, believing that celebrity will make him safer, combat the aura of clandestinity, and reduce the curiosity generated by the very anonymity Wikileaks is proud to guarantee. There is talk of Wikileaks heralding a new model of journalism and publishing, and many frontline journalists believe this, anxiously wondering how to cope with the tsunami of secret logs being released via Wikileaks. The question we posed in *Afflicted Powers* vis-à-vis the images of September 11 nevertheless remains: whether the circulation of atrocities caught on camera—in Iraq, Afghanistan, Gaza or elsewhere on the imperial frontier—could lead to real destabilisation. Even to frame such a question points to the new historical conditions.

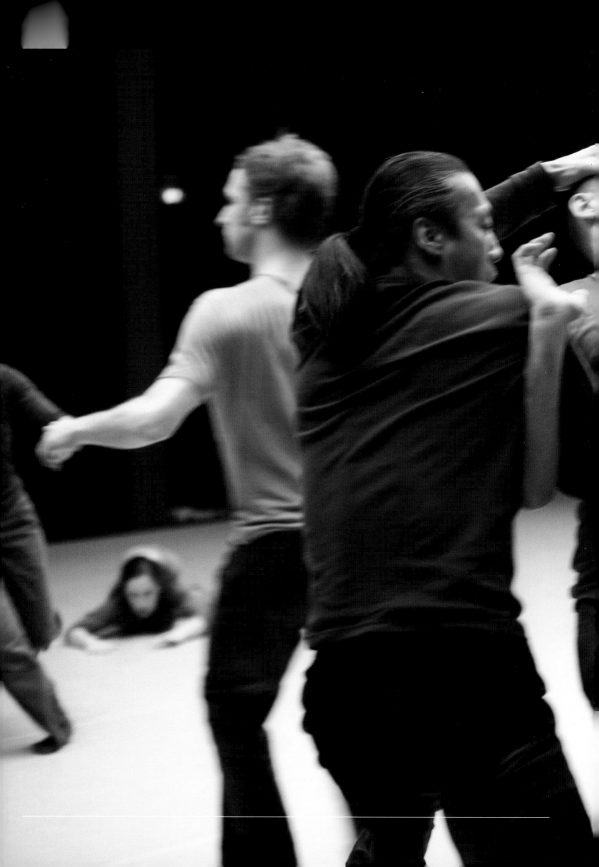

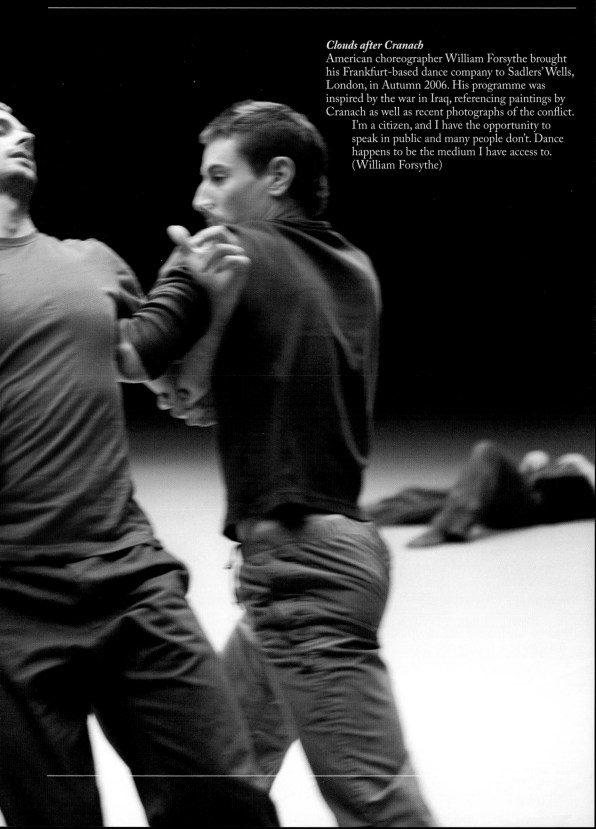

Clouds after Cranach
American choreographer William Forsythe brought
his Frankfurt-based dance company to Sadlers' Wells,
London, in Autumn 2006. His programme was
inspired by the war in Iraq, referencing paintings by
Cranach as well as recent photographs of the conflict.
 I'm a citizen, and I have the opportunity to
 speak in public and many people don't. Dance
 happens to be the medium I have access to.
 (William Forsythe)

Rotten Sun

The myth of Icarus.... clearly splits the sun in two—the one that was shining at the moment of Icarus' elevation, and the one that melted the wax, causing failure and a screaming fall when Icarus got too close.

Georges Bataille, *Rotten Sun*, 1930.

Rut Blees Luxemburg, *Rotten Sunrise*, 2010.

Julie Marsh, *Into the Light*, 2009.

PLATE XXV

SILENT WATERS ANTHONY PEACOCK, F.R.P.S.

Dominic Shepherd, *Black Sun*, 2008.

Dave Hazel, *Untitled*, 2005.

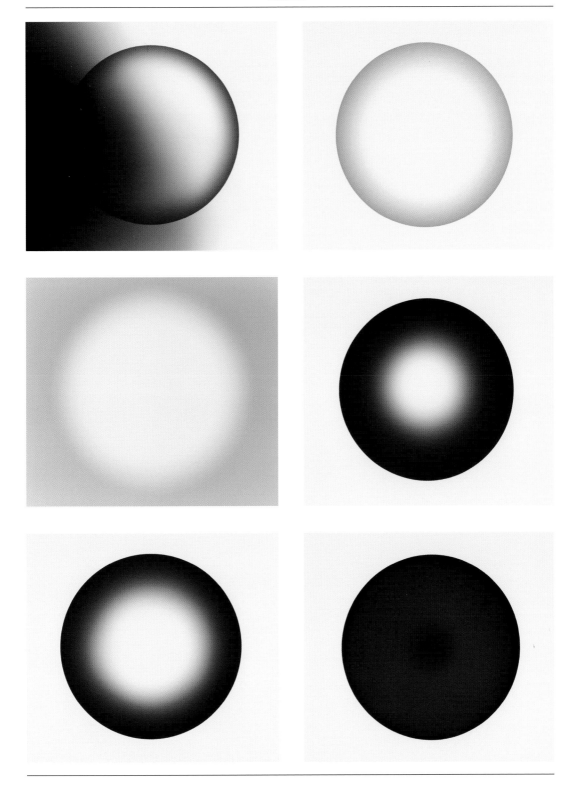

R

Penelope Umbrico, *Flickr Sunsets*, 2010.

Spectre

Ein Gespenst verlässt Europa (*A Spectre is leaving Europe*) is a book published in Cologne in 1990 by the writer Heiner Müller (1929–1995) and the photographer Sibylle Bergemann (1941–2010). The title alludes caustically to the ominous boast of Karl Marx and Friedrich Engels that famously opens *The Communist Manifesto* of 1848: "A spectre is haunting Europe— The spectre of Communism." Müller and Bergemann had both lived and worked in the German Democratic Republic (East Germany) and their book is a response to the rapid collapse of a staunchly pro-Soviet regime that began during 40th birthday celebrations in 1989, and concluded with political unification with the Federal Republic of Germany (West Germany) in the following year.

The book includes ten poems by Heiner Müller plus a suite of photographs by Sibylle Bergemann that officially record the creation and installation of what proved to be one of the last Communist monuments in Europe. In 1974, East German sculptor Ludwig Engelhardt received a commission to create a memorial spot for Marx and Engels in East Berlin that would have a sculpture of the two founders of Communism as its central focus, and in 1986 the Marx-Engels Forum was officially opened by the President and Party leader, Erich Honecker. (The statue is still standing, though the parliamentary building originally behind it, Erich Honecker, and the German Democratic Republic, are all long gone.)

The Party's underestimation of the critical potential of photography provided opportunities and recent commentators have been keen to identify Bergemann as a discreet dissident. Such a perspective informed her recent retrospective at the German Academy of the Arts, Berlin. The catalogue essay of Matthias Flügge, for example, associates her with the "subjective 'author' photography" that emerged in the GDR in the 1970s, and the photographs "demonstrate her ability to penetrate far below the polished surfaces of an apparently controlled, pseudo-egalitarian society". For Flügge, her 'magnum opus' is the documentation of the Marx-Engels Forum: "images which showed what the end would be, right at the beginning"; "icons of futility".

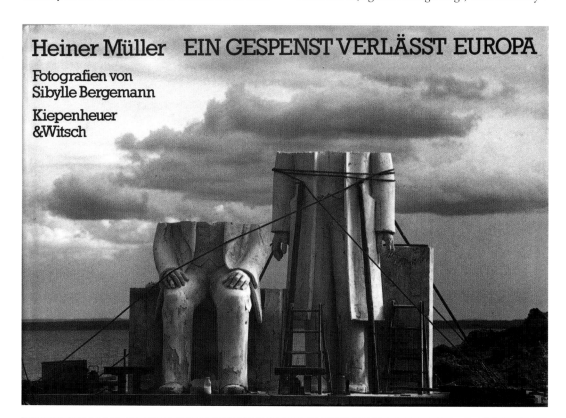

top/ David Evans, *Spectre*, 2011.

bottom/ Heiner Müller and Sibylle Bergemann, *A Spectre is leaving Europe*, 1990.

Stone Breakers

In the late 1980s, a Professor of Art History at Humboldt University, East Berlin, published a history of proletarian art. The cover shows a reproduction of Gustave Courbet's now destroyed painting from 1849 called *The Stone Breakers*, treated in the book as a major achievement in the pre-history of Socialist Realism. In November 1989, photographs of individuals banging away at the Berlin Wall with their hammers traversed the globe. Here was another example of how to philosophise with a hammer.

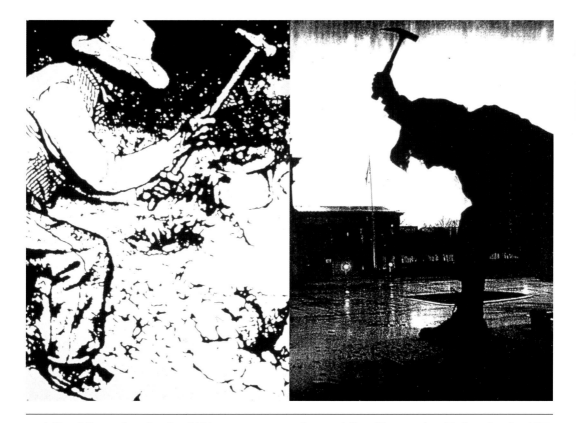

top/ David Evans, *Stone Breakers*, 2011. **bottom/** Poor Photographer, *The Stone Breakers*, 1989.

Surrealism

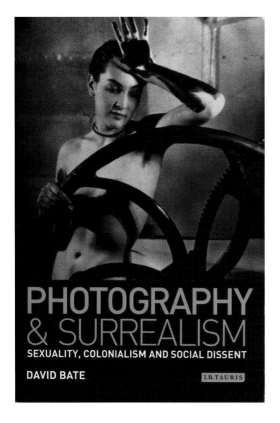

Are you, or have you ever been, a card carrying Surrealist?

No.

Ditto, Lacanian?

No

Why do you carry a fish in your breast pocket?

Ah—the fish! Well, it was made of plastic! The fish was used at the book launch as a form of 'memory object'. It is a bit like the Surrealist 'dream object' where an object operates as a 'likeness' for a mental image or dream. This is also an Ancient Greek idea in teaching the art of memory. Essentially, this is the rhetorical strategy of using an image-object and to locate within that object certain points to remember for a speech. (Very useful if you worked in the Ancient Senate and had to give long speeches!) So, for example, the mouth of the fish used to remind me that it is the organ for speech as a way to remind me to thank the people who enabled me to speak by publishing the book, etc.. So you see, in this sense, the fish was not a fish.

Are you the Anti-Krauss?

What a great question! No, she is! Rosalind Krauss re-oriented the study of Surrealism in the 1980s. Her idea was that you could understand all Surrealism, or at least its visual works, by thinking them through the logic of photography. In some sense this is true. The Surrealists were certainly hostile to mimetic representation. So if photography was the dominant form of mimetic representation, that might be an interesting way to examine Surrealism. My problem with this is that Surrealism used

David Evans, *Fish in Pocket: an interview with David Bate*, 2004.

photography in different ways, as mimetic and as, in various ways, anti-mimetic. This is where my book starts out. It considers the fact that the Surrealist use of photography as a medium cannot be reduced to an aesthetic definition, which is what I think she tries to do: looking for the 'essence' of a Surrealist photographic image.

The other point to make about Krauss' writings on Surrealism is that this whole argument she makes about re-centring the study of an 'art' like Surrealism through photography can be read allegorically as a symptomatic argument about the contemporary art of the day. It is obvious to me that her argument is being made at precisely the same time that photography—in the form of "Post-Modern" New York artists using photography like Cindy Sherman, Barbara Kruger, *et al*—was taking centre stage in contemporary art. In this respect, Krauss' turn away from painting to photography represents the rejection of her own Greenbergian Modernism. But what she takes to the debate on photography and Surrealism is precisely the emphasis on formalist argumentation. This brings some interesting points out, but what *is* lost in it is any sense of the historical location of the images and ideas that she discusses. Consequently, there are people who think that Georges Bataille was a key figure of Surrealism when, in fact, he was never actually a member of the Surrealists. I do not wish to be pedantic, or even really criticise Krauss for all this, after all her work brought about a renewed interest in Surrealism. But surely the difference between history and formalist criticism needs to be articulated somehow?

(This e-mail interview with David Bate was published in the first issue of *criticaldictionary.com* shortly after the publication of his book *Photography & Surrealism: Sexuality, Colonialism and Social Dissent*, 2004.)

Television

Television:
a "museum of horrors",
a "tunnel of death",
an altar of human sacrifice...

Paul Virilio, *Unknown Quantity*, 2003.

Penelope Umbrico, *Broken Sets*, 2009.

T

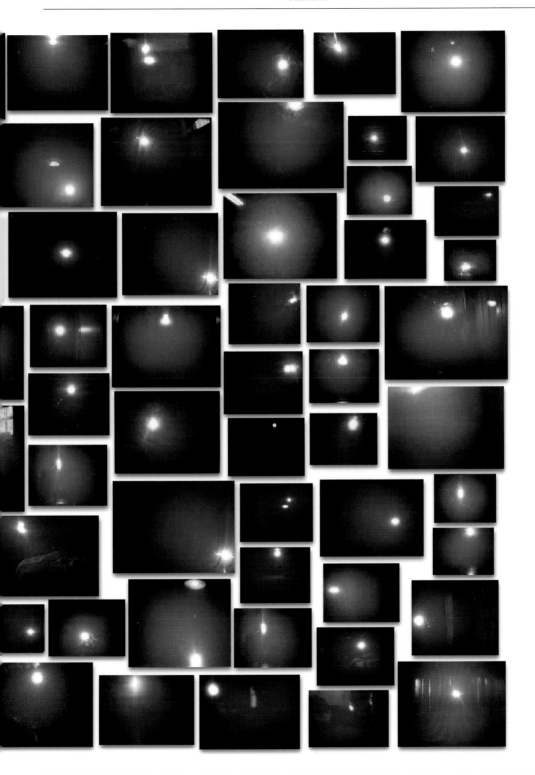

Penelope Umbrico, *For Sale/TVs from Craiglist*, 2009.

Thing

The world is due for a resurgence of original speculative metaphysics. The *New Metaphysics* series aims to provide a safe house for such thinking amidst the demoralising caution and prudence of professional academic philosophy. We do not aim to bridge the analytic-continental divide, since we are equally impatient with nail-filing analytic critique and the continental reverence for dusty textual monuments. We favour instead the spirit of the intellectual gambler, and

Ordinarily, upon hearing the word 'object', the first thing we think is 'subject'. Our second thought, perhaps, is that objects are fixed, stable and un-changing, and therefore to be contrasted with events and processes. The object, we are told, is that which is opposed to a subject, and the question of the relation between the subject and the object is a question of how the subject is to relate to or represent the object. As such, the question of the object becomes a ques-tion of whether or not we represent the object.

()

OPEN HUMANITIES PRESS

ISBN 978-0-9805440-5-3

90000

9 780980 544053

Cover design by Katherine Gillieson · Illustration by Tammy Lu

New Metaphysics, series editors: Graham Harman and Bruno Latour, 2008.

wish to discover and promote authors who meet this description. Like an emergent recording company, what we seek are traces of a new metaphysical sound from any nation of the world.

The editors are open to translations of neglected metaphysical classics, and will consider secondary works of especial force and daring. But our main interest is to stimulate the birth of disturbing masterpieces of twenty-first century philosophy. Please send project descriptions (not full manuscripts) to Graham Harman, gharman@aucegypt.edu. Open Humanities Press is an international Open Access publishing collective. OHP was formed by scholars to overcome the current crisis in publishing that threatens intellectual freedom and academic rigour worldwide. All OHP publications are peer-reviewed, published under open access licenses, and freely and immediately available online through www.openhumanitiespress.org.

Levi Bryant *The Democracy of Objects*

New Metaphysics

Tammy Lu, drawing and Katherine Gillieson, cover design, *Levi Bryant: The Democracy of Objects*, 2011.

Touch

Six centimetres high and reassuringly heavy, the pendant sits perfectly in the palm of my hand, smooth, cool and substantial, its metal and glass aesthetics reminiscent of the gadgets we now use to carry photographs about our body. A Daguerreotype and a lock of hair, delicate remains from about 1840–1850, are held safe within bivalves of glass. As fashionable as an iTouch today, this too was new technology, photography, revitalising an older format, eighteenth century miniature-and-hair jewellery. The woman in the portrait is wearing a round broach that too might have held a portrait. It marks a bellybutton at the centre of the composition: folds of fabric and hair corkscrew out into the frame and spill into the folds of my hand. The impregnability of the pendant melts into tactile fantasies that animate the otherwise anonymous Daguerreotype, and bring its accuracy to life. I am teased into longing to touch, to feel if her ringlets are stiffened with sugared water or grease, if her dress is heavy silk or the cheap stuff rustling like tin-foil in nineteenth century novels. How promising her lips, stubborn her chin and worrying her cheek, not plump enough to fill the palm of my hand as the pendant does. I can't touch her, but whoever wore this might have been able to. I find myself hoping his or her touch was as delicate as mine has to be here in the archive, where conservation has replaced affection. Unlike vision, touch can never pretend to be distant and neutral. Touch is reciprocal, contaminating, and has effect/affect, whether caressing or destructive, welcome or intrusive.

Mechanically produced yet a one-off, negative and positive, the image on a Daguerreotype is but a dusting of mercury and oxidised silver, so fragile it has to be kept behind glass. In this pendant, this complex technology is mixed with the simple materiality of hair—two cuts into the referent joined back to back, one facing eyes the other skin. The craftsmanship of the setting honours the metaphorical richness of photography, embalming precious bodies in silver, traditionally the material of reliquaries. Not diamonds

Anon, *Gold pendant containing a Daguerreotype portrait and a lock of hair* (front), c. 1850.

Patrizia Di Bello, *Touch*, 2011.

as a girl's best friend, but the best girl as a diamond. The light that touched her, so long ago, metamorphosed into silver dust deposited by her luminosity is now shining like a star, intensified by the sacrificial regard implied by the jewel. The pendant knows that photographs are like diamonds, past hardened into present. It carries the photograph like the photograph carries the referent, laminated together; it is in turn meant to be carried by a person wearing it. The there-and-then of the photograph is transported into here-and-now as an adornment. The past is reanimated, put into motion not by a machine, as film is, but by a living body performing everyday gestures—putting on the pendant, pausing for a moment of reverie, and then loosing consciousness of it until it becomes something to play with in moments of boredom, or finger absent-mindedly while concentrating on something else.

As fashionable accessory, the photograph loses some of its mournful connotations to acquire more of the shining sex appeal of the commodity—one fetish into another. The uncanny starts to wear off, as bodily contact warms it up, brings it back home and turns it into an object of play. Held by the swivel hoop, the pendant revolves smoothly on its axis; slowly, the portrait appears, turns into a ghostly negative, reflects my face, disappears behind the lock of hair, and then reappears. I am playing peep-ho with a dead woman. The pendant will not tell me who she was, yet it generously reciprocates my touch, with its rich response to my handling. This is crucial to the pleasure of all photographs. Holding prints, leafing through album pages, clicking a mouse or swiping a screen: how quickly boredom sets in when someone else is doing the touching! It is not just that photographs can be held but that the fantasies engendered by details so rich they stimulate the tactile receptors of the brain, are enhanced by our presumption that they are unmediated by human hands. An example of things as theory, the pendant reminds us that photographs address touch as much as vision.

Anon, *Gold pendant containing a Daguerreotype portrait and a lock of hair* (back), c. 1850.

Umfunktionierung

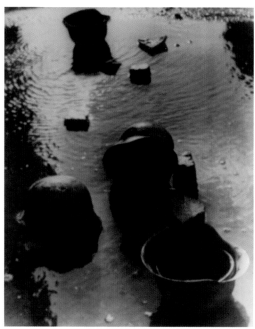

Look at the helmets of the vanquished! Yet
Surely the moment when we came undone
Was not when they were smitten from our heads
But when we first agreed to put them on.

War Primer—*Kriegsfibel* in German—is a collection of what Bertolt Brecht called "photo-epigrams", four line verses captioning photographs clipped from newspapers and magazines. They were mainly composed during World War Two, while Brecht was living in Scandinavia and the United States as an exile from Nazi Germany. Edited by his Danish collaborator, Ruth Berlau, they were finally published as a book in 1955 in the German Democratic Republic (GDR), Brecht's home base from 1949 until his death in 1956. Astonishingly, an English language edition only appeared in 1998. This edition was the work of Brecht scholar John Willett and Libris, an independent publisher in North London that specialises in German Studies.

War Primer merits attention for two reasons: first, it represents Brecht's most sustained, practical engagement with photography; second, it was notably absent in the discussions about Brecht and photography which reached their apogee in the 1970s, in Britain at least.

War Primer can be viewed as the *Umfunktionierung* or "functional transformation" of mainstream press photographs though the addition of alternative captions, informed by Brecht's Communist politics. But it is more. If the choice of the epigram is meant to suggest ancient inscriptions, then the press photograph has plausibility as the equivalent to the ancient statue or building for which the epigram was originally intended. That is, *War Primer* is a series of portable monuments, flat memorials to World War Two.

In addition, *War Primer* can be understood as a homage to Lenin, a leader who had little time for traditional monuments. In Brecht's project there are no heroes, no statues, no stone, no bronze. Not even the impermanent plaster favoured by Lenin for an abandoned series of temporary monuments to teach revolutionary, proletarian civics. Instead, Brecht uses paper images cut out of newspapers and magazines. For Kracauer, such photographic ephemera are an aid to forgetting. For Brecht, however, they have a potential use value. Combined with his epigrams, the carefully selected images become poor monuments, an aid to critical remembering.

(The above is adapted from: David Evans, "Brecht's *War Primer*: The 'Photo-Epigram' As Poor Monument", *Afterimage* 30.5, March/April 2003. Translation: John Willett, *War Primer*, London: Libris, 1998. Thanks to Nicholas Jacobs, Libris, for permission to use this material.)

Bertolt Brecht, *War Primer*, 1998. David Evans, *Umfunktionierung*, 2011.

Variable Capital

DAVID EVANS: Why did you choose to call yourselves Common Culture?

COMMON CULTURE: Common Culture emerged out of conversations between David Campbell and Paul Rooney and developed into the collaborative project that now includes Campbell, Mark Durden and Ian Brown.

It was originally conceived as a means of making art in response to the chauvinistic promotion of 'Young British Art' by prominent sections of the art establishment. As artists based in the North of England we were intrigued both by the claims of radicalism made by the cultural administrators in London for this new art and the notion of 'Britishness' it proposed. As a response, Common Culture began to make art exploring notions of Britishness, class identity and commodity culture from the perspective of our own social and geographic situation. The name Common Culture was prompted by reading Tom Crow's *Modern Art in the Common Culture* and reflected our wide-ranging interest in popular forms of culture.[1] Since we are living in Britain our cultural references reflect specific local experiences associated with this country that are nonetheless framed and determined by global forces.

DE: Why the interest in fast food?

CC: We were only interested in illuminated fast food menus to the extent that they provided us with ready-made and familiar forms of commercial signage that could be adapted to reflect our interest in issues of taste, consumption and cultural identity. Our motivation was the opportunity to pit different forms of cultural consumption against each other, creating an awkward and self-conscious reception of the work for the viewer. We saw the light box form of the menus having corrupting allusions to Minimalism, the work of Donald Judd and Dan Flavin especially.

We first exhibited this work in New York at the time of global interest in Young British Artists. The Menu work was about staining and soiling the pure forms of American High or Late Modernism with a vernacular trace of common transaction. And the whole fast food cuisine listed was in some ways an affront to the more refined tastes of the wine-sipping gallery visitor.

DE: Recently you have been working with bouncers. So has Melanie Manchot, making videos of club bouncers on Ibiza who are asked to strip for the camera and in the process become uncharacteristically vulnerable. How does your project differ from Manchot's *Security*?

CC: There is no relation for us. Our work with *Bouncers* originated in questions to do with the commodification of labour power and the extraordinary power of the look these workers have. We were interested in using this within the context of the gallery, positioning this kind of looking in relation to that of the art audience. The work has different forms, performances, videos and a series of still photographs.

Throughout this work and others, *Local Comics*, *Mobile Disco* and *Tribute Singer*, we have contracted people to work for us. In his respect, our practice has closer affinities with Santiago Sierra, an artist who was very important to our current book and show, *Variable Capital*. Sierra, like us, is interested in disrupting the exchange between viewer and artwork. Only his work is much more blunt and brutal in its exposé of what money can make people do. His art confronts us with global economic inequities. Sierra's target and context is the international art market. Our work with people representative of familiar aspects of British culture is much more specific and local.

DE: A series of photographs from 2007 is called *Binge* dealing with the drinking sprees by young men and women that are now an established component of British urban culture. Are you endorsing William Blake's famous suggestion that "The road of excess leads to the palace of wisdom"?

CC: No. It is a response to excess within British culture. In counterpoint to the disciplined and physically present bodies of the *Bouncers*, *Binge*

David Evans, *Variable Capital: a conversation with Common Culture*, 2008.

focuses on states of satiation and abandonment, of collapsed bodies in the urban night scene. We do not celebrate excess but simply draw attention to the spectacle of people who have over-consumed. The *Binge* photographs and our earlier *Menu* work represent related stages in a dialectic of consumption. The *Menus* reference the signage used to incite consumption, while the *Binge* photographs chart its aftermath.

DE: You have just curated a show at the Bluecoat, Liverpool, called Variable Capital.[2] Could you explain the title and say something about the thinking that informed this very ambitious exhibition?

 CC: The title borrows a term used by Karl Marx to describe the proportion of capital invested in wages in the purchase of labour power. According to Marx it was this proportion of capital that produced a new, surplus value in the course of the labour process, over and above that paid to the worker as wages. Marx identifies this investment as the only one that creates new value, because the worker is able to produce more than he needs in order to live.

 Variable Capital creates the capitalist's profit and is also the site of exploitation. Our show and book looks at art's critical engagement with consumerism from Andy Warhol to the present. And looks at it within a global context—from Louise Lawler's swanky photographs showing details of artworks for sale in the auction room to the video showing the repair of broken domestic appliances staged in a gallery in Caracas, by the Venezuelan artist, Alexander Gerdel. Art is of course the ultimate commodity and in many ways Lawler is key to the show in drawing attention to this, but there is also a focus on the role of workers and their deployment and exploitation as variable capital.

DE: You have created a tie-in book also called *Variable Capital*. It is published by Liverpool University Press, although it does not feel like a conventional academic publication. It's a large, sumptuous, full-colour production, wrapped in a cover of re-cycled cardboard. Most obviously, you are alluding to the packaging that ensures that hi-fis, home cinemas, flat panel tvs and the like arrive in our living rooms undamaged, but I also noticed references to cardboard throughout your book. For example, an important section called "Exploitation" considers the work of Santiago Sierra, especially the major piece *Workers Who Cannot be Paid, Remunerated to Remain Inside Cardboard Boxes*, 1999. Could you say something about the thinking that informed the design of the book?

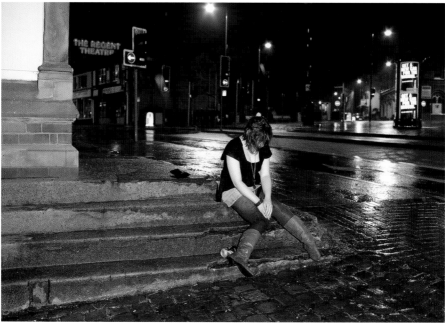

CC: The design of the book came about through a close relationship with an excellent design team in Liverpool, Lawn Creative. We wanted a look that signaled the book's involvement with the traffic of commodities. The discussion with Lawn Creative centred on how to come up with a design for the book that would register its own status as a commodity, albeit one containing a critique of consumerism. Stephen Heaton, the designer at Lawn, proposed foregrounding the grubby reality of commodity transaction through the use of reclaimed cardboard packaging lifted from supermarket skips. As this material already carried the signage of its original life as commodity packaging and the utilitarian trace of its circulation and consumption, it was the perfect material with which to introduce the *Variable Capital* project. As a result of using the 'found' cardboard for the cover, each book is slightly different, bearing the signage, the brands and logos, for the products it once contained. To this extent each example is unique, a fact we further emphasised by giving each copy its own edition number.

The interior of the book is deliberately lavish and we wanted this contrast between the packaging and the product inside, beautiful colour images and a text that is quite detailed and academic but is presented in an enticing way. There was also a

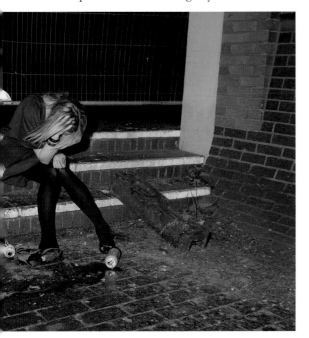

'Trojan Horse' quality offered by the cardboard cover; a familiar material masking something potentially disruptive. Cardboard clearly signifies its status as a transient and disposable material, it is used in relation to materials and products deemed to be of greater value and status, it is always on the brink of being surplus to requirement and discarded. In this sense, its exploitation and abandonment is akin the capitalist's treatment of human labour power, a central theme of the *Variable Capital* exhibition and book, so it seemed like an appropriate choice. You are correct in identifying a point of connection with Santiago Sierra's *Workers Who Cannot be Paid, Remunerated to Remain Inside Cardboard Boxes*. For Sierra the cardboard boxes serve to both cite the abstract geometric forms of Minimalism and commodity packaging. Cardboard as low and cheap material also was important as a contrast to the shiny seductive allure of the fetishised commodity and taps into what we refer to as work concerned with a thrift environment, the photographs of thrift stores by Brian Ulrich and the work of the British artist, Richard Hughes, who produced a specific piece for the exhibition that consisted of a meticulous fabrication of the cardboard packaging someone had been using as bedding in a street doorway.

DE: The book has 26 sections, each given a curt title, usually of one word. The order isn't alphabetical, yet the impression is of a dictionary of contemporary capitalist culture. Can your project be understood as a visually-led version of *Keywords: A Vocabulary of Culture and Society*, 1976, by Raymond Williams?

CC: The text can function like a dictionary, or as an ironic product range, but it is not the last or final word on the subject. It is important that the text was co-written and we wanted to get away from the form of the academic essay. The task was to produce a book that was seductive as well as critically engaging. The layout and the design mimics the presentational style of product promotion. The titles you refer to are there to entice, like the descriptions of dishes on a menu or goods in a product catalogue. The purpose of all this was to explore how artists have critically engaged with contemporary cultures of consumption and have done so knowingly, fully aware of their own status as producers of high-end commodities. The book was conceived as a partner to the exhibition of the same name at the Bluecoat, Liverpool. It was meant to provide a

opposite and above/ Common Culture, *Binge*, 2007.

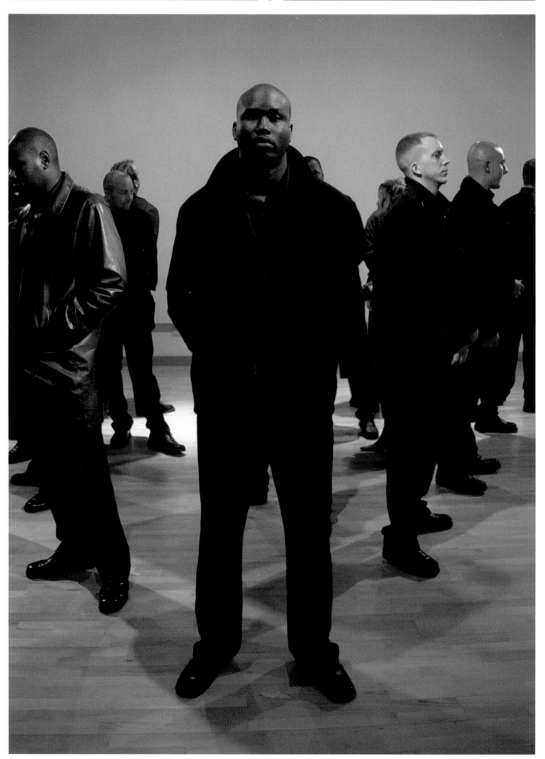

Common Culture, *Bouncers*, 2005.

wider historical context for the artists we selected for the show, but the Bluecoat also brought its own context. Positioned as it is amidst a massive retail redevelopment of the city centre, the visitor to the gallery stepped immediately from Liverpool's culture of capital with its bountiful new department stores into the Variable Capital exhibition. The friction with this context, and the visitors' experience as consumers, was just as important to us as mobilising the historical context of commodity critical art.

DE: Jeff Wall is discussed in a section called "Bad Goods", the title of one of his well known works from the mid-1980s that foregrounds rotting lettuces (and more cardboard) in a suburban wasteland. You cite Wall's claim that his staged images continue a critique of documentary realism, but without the Brechtian or Godardian strategies of distanciation that had become 'formulaic and institutionalised' by the mid-1970s. Then in your "Conclusion", you describe the work of Common Culture as a "Brechtian art [that] disrupts the familiar transactions underlying the experience of aspects of British popular culture." Do you see yourselves—as artists and curators—re-opening a debate about the use value of Brecht that many, like Wall, assumed to be closed some time ago?

CC: Yes, we do see our work as Brechtian in its disruptive and awkward relation to the viewer. We want a work that is unredemptive, that sets up a relationship with the viewer that is uncomfortable. Wall's work sits too easily within the white cube art gallery, the potential brashness of the back-lit light box is countered by the art historical quotations his art make. Artists like Sierra are Brechtian and particularly uncompromising in their display of situations of exploitation within the gallery. Through the text, with its shopping list quality of organisation and again in the exhibition, we were keen to develop the conditions where the reader or the viewer became aware of the possible relationship between the different work and the social situations to which they referred.

DE: Naomi Klein's recent book *The Shock Doctrine: The Rise of Disaster Capitalism* vividly articulates the suspicions of many—that the so-called War on Terror is above all a new, aggressive phase of capitalist development. Yet *Variable Capital* contains nothing directly related to this topic. Rather, its emphasis on American art of the 1980s that dealt with the surface allure of consumer culture (Jeff Koons, say),

contrasted with work from the same period that deliberately reveals the usually hidden labourer (Alfredo Jaar, perhaps) seems to imply that Klein and others are exaggerating the economic significance of the so-called War on Terror.

CC: *Variable Capital* is the beginning of a much bigger project that will take the form of another book. The idea of Disaster Capitalism is relevant and contemporary and will no doubt impact upon how we develop the project. Klein's argument is not an exaggeration, but part of the wider global picture. But what was important in our conception of this project was to begin to track a recent art history that had not really been critically written. Our point of reference was the much more celebratory exhibition at Liverpool's Tate, Shopping—A Century of Art and Consumer Culture. Our *Menus* were included in this show, but rather off stage, occupying the site of an un-rented shop on the dockside. Shopping included works by Koons, Prince, Steinbach, all artists we are interested in, but the show never really raised critical issues about their relation to consumerism. Our book discusses Neo Geo in contrast to the differing relations to a documentary photographic tradition that emerged in the 1980s, including work by Alfredo Jaar, Martin Parr, Paul Graham and Jeff Wall. Yet, with our interest in Brechtian strategies of disruption, such recourse to realist modes was never seen as the answer.

———

1. Crow, Thomas, *Modern Art in the Common Culture*, New Haven and London: Yale University Press, 1996.
2. Variable Capital, Bluecoat, Liverpool. 16 May–29 June 2008. The exhibition includes work by Edward Burtynsky, Common Culture, Alexander Gerdel, Richard Hughes, Melanie Jackson, Louise Lawler, Hans Op de Beeck, Wang Qingsong, Julian Rosefeldt, Santiago Sierra, Larry Sultan, Brian Ulrich and Andy Warhol.

(David Campbell and Mark Durden, *Variable Capital*, Liverpool: The Bluecoat and Liverpool University Press, 2008. Distributed in the USA by the University of Chicago Press.)

V

Vers une Architecture

THE PARTHENON
The plastic system

Voice

Norwegian musician Maja Ratkje discusses the art of the record cover with Åsa Maria Mikkelsen. They met at Maja's house near Oslo in November 2006.

"The cover means a lot to me, just like the order of the tracks. Together it makes an object that should be dealt with in its entirety."

Voice/ "Kim [Hiorthøy] took a picture of me and said he was going to make a drawing based on the photo. When I got the cover for approval he had used the photo instead of the drawing he had made... I hesitated a while before I approved because I found it too personal."

Spunk (2)/ "We had a lot of strong opinions about the first cover, but now we just get to see a pdf with the right to veto. He [Kim] always presents finished work. Never work in progress. It seems he likes working undisturbed, and then it's take it or leave it. But I don't think that anyone has ever left it!"

Spunk (1)/ "We wanted something turquoise and we had long conversations about it. He [Kim] was handed colour charts and everything. When he was done there was a yellow CD in the mailbox! It is about trusting someone who is good at something."

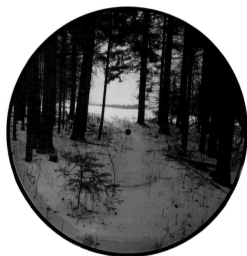

Music for Shopping/ "Lasse Marhaug is a noise musician and a graphic designer.... When we produce these records [*Music for Shopping, Music for Loving, Music for Faking*] we meet for one day. We bring samplers, minidisc players and various recording instruments, and combine things from our records and other sources like TV.... One hour of record material is then edited down to 45 or 50 minutes, and we publish it! It's all done very quickly and Lasse makes the cover, inspired by the occasion."

Stalker/ "The starting point for this production was the record company's [Important Records] idea of a collection of my music on a picture disc which is a highly sought after object amongst record collectors. The company wanted a picture of me on either side, and they made a selection from the ones I had on my website.... After I had accepted that image, I was allowed to start making the other side...."

opposite and above/ Åsa Maria Mikkelsen, *Covering Maja Ratkje*, 2006.

Volk

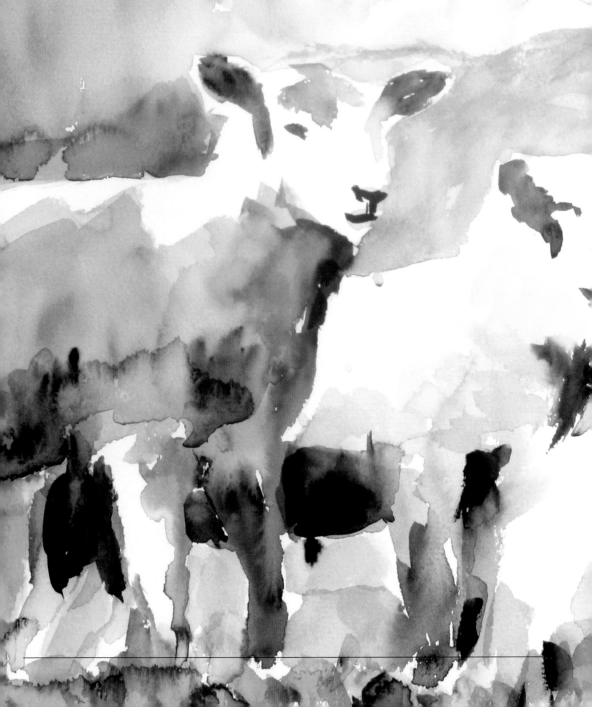

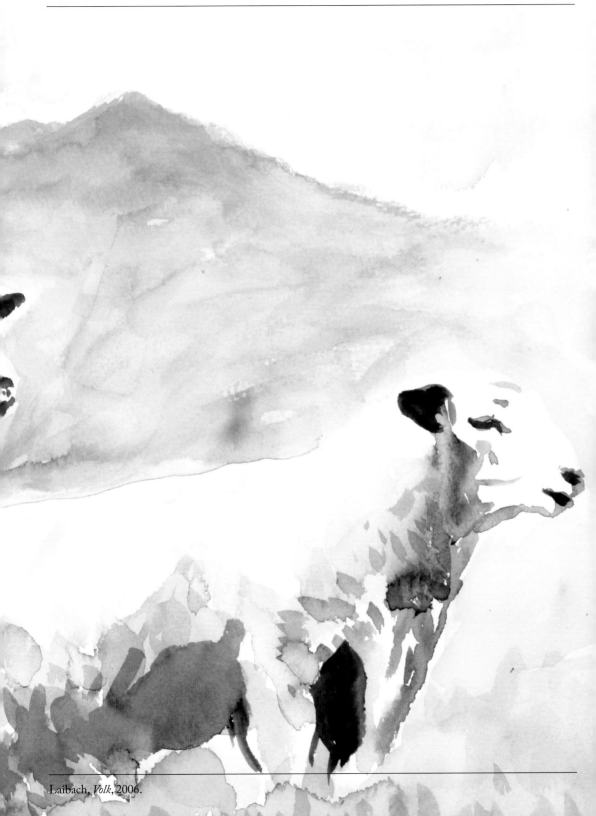

Laibach, *Volk*, 2006.

V

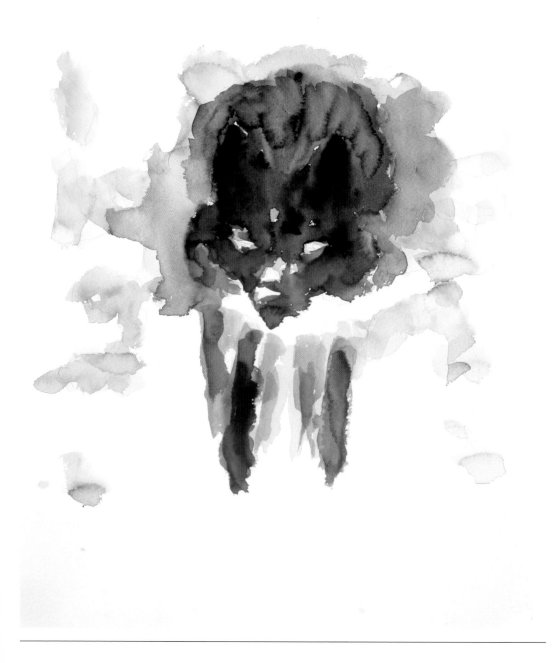

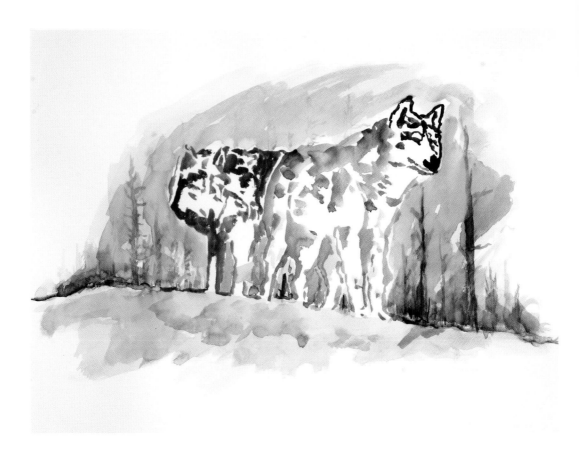

opposite and above/ Laibach, *Volk*, 2006.

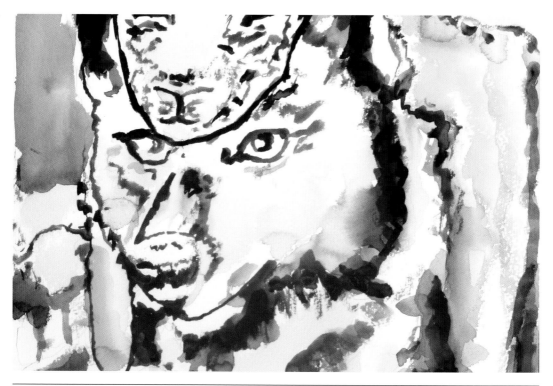

above and opposite/ Laibach, *Volk*, 2006.

Volk is a concept album by Slovenian industrial group Laibach. The album is a collection of 13 songs inspired by national or pan-national anthems, plus the anthem of the NSK (Neue Slovenische Kunst) State, a virtual state to which Laibach belong. The album is a collaboration with another Slovenian band Silence. The album's liner notes credit Wikipedia as their source for information on the national anthems featured.

Wikipedia, *Volk*, 2006.

Walk

The work I am presenting is a part of my long-term project *Night Promenade* that deals with night scenes in small towns in Serbia. The images feature young people going out on the main streets and pedestrian zones of the provincial towns of Krusevac, Vranje, Cacak, Cicevac, Bor and others.

Ivan Petrovic, *Statement*, 2011.

Ivan Petrovic, *Night Promenade*, 2011.

opposite and above/ Ivan Petrovic, *Night Promenade*, 2011.

DAVID CAMPANY: We are at the foot of Waterloo Bridge looking at a flight of steps you photographed in...?

RUT BLEES LUXEMBURG: 1997.

DC: It's changed since then. The text that appears on the wall in your image—a text that looks like a poem that has been crossed out or covered over—has almost disappeared. What first drew you to this site?

RBL: *Liebeslied* has become the overall title for a body of work and for my second book. For me the *Liebeslied* was this elusive writing on the wall which seemed always more than just graffiti or some quick communication. Even when I first saw it, it was indecipherable. I think that the writer tried to eradicate it, just after writing it. And now it has become a stain or trace, adding to all the other stains on the surface of the city. I like the curves, they are so baroque that they suggest something much more palatial, or sacred, instead of a cold, outdoor space.

DC: It looks like a very private form of communication, the opposite of most graffiti or street writing which might tend to be a disenfranchised citizen announcing something to the world in general. The poem seems like one soul speaking to another soul but within a public place.

RBL: Yes, that's why for me it became a *Liebeslied*. It is very considered. The scale is intimate. It is writing at the scale of the body.

DC: Which is also the scale of the page.

RBL: So I came and photographed it. It seems private. I'm attracted to the *Heimlichkeit* of a space in public. A space that allows for a moment of repose.

DC: Do you think that repose comes from the places or from your images?

RBL: From the places, most definitely. It is hard for me to photograph places where I don't have that feeling or relation. The images then try to trace that sensibility.

DC: I think of your work as almost the opposite of street photography which we associate with bright daylight, people, grabbed chance instants and speed, instantaneity. Here we have long duration, emptiness, a shell that becomes a content, rather than the other

way around where in street photography people become generalised ciphers of the masses. In your work the population is either moving through—coming or going—or absent.

RBL: Well the 5 x 4 camera is the opposite of what the street photographer would use. It requires slowness and concentration and the exposures are long. Ten, 15, 20 minutes. So it's another kind of street photography. Or maybe 'street' isn't even important. 'Public' photography is better.

DC: Your photographs are often of streets or contain streets.

RBL: Well in the newer work the street is becoming less significant for me. In my earlier work, collected in the book *London: A Modern Project*, the street was much more important. Now it's other places.

DC: There is generally much more intimacy in your recent work. You have moved away from the great heights and the monumentality of the built city.

Rut Blees Luxemburg and David Campany, *Why don't we walk along the river? A Conversation*, 1999.

Rut Blees Luxemburg, *Liebeslied*, 1997.

RBL: That's a deliberate move. The idea of the *Liebeslied* suggests that intimacy of communication. An attention to another experience of the public. Not the great, grand declamation but the small theatrical spaces and gestures. Shall we go further along the river?

DC: OK, we're at the site of a picture called...?

RBL: *Nach Innen* or *In Deeper*.

DC: The title seems to refer back to a quote by Roland Barthes that Michael Bracewell used in the introduction to your first book, if I recall.

RBL: Yes, yes: "To get out, go in deeper." It became the motto for this newer work, in a way. Deeper, closer to the ground.

DC: You can't get much closer to the ground than the water, or sea level.

RBL: Well the interesting thing about the sea level is that it moves, as we saw, it changes within a couple of hours.

DC: This suggests interesting questions of duration and long exposure and the subtleties of changes. I'm reminded of a great little essay by Jeff Wall called "Photography and Liquid Intelligence". He's talking mainly of how the instantaneous picture can show forms that are unavailable to human vision, but I think the long exposure of moving water does something equally specific to photography. This soupy, syrupy quality.

RBL: And here a very golden quality to water as it is lit. This image is also very much about absence. You see the footsteps on the mud? They are expressive of something that runs right through the *Liebeslied* series, which became about a possible poet who is wandering the city in a way that is in contrast to the *flâneur* made famous by Baudelaire. The *flâneur's* relation to the city is very much about a pleasure or diversion. The poet's wandering is more about an encounter.

DC: I remember in Alfred Hitchcock's *Vertigo*, James Stewart asks if he can accompany the wandering Kim Novak. She replies that only one person can wander, two are always going somewhere.

Rut Blees Luxemburg, *Nach Innen/In Deeper*, 1999.

RBL: I think that's true. I do walk alone although occasionally when I come to shoot on large format I'll take an assistant, but by that stage the wandering has been done.

DC: There has been a lot of recent discussion about the *flâneur* and the contemporary city, partly as a response to new forms of spectacle, and partly, for political reasons to open up the city and break the alienated, uncreative habits into which city dwellers fall or are coerced. But the wandering of the poet is far more contemplative, it seems. Perhaps more difficult or painful.

RBL: I wouldn't call it difficult. It's a different daring. To dare to have this encounter, which might be an encounter with the self, or with what goes beyond the experience or appearances. It looks deeper to levels of experience beneath. In that way it can be much more political than the *flâneur* whose distraction fits in so well with the city's diversions.

DC: The more recent work is spatially more intimate. It is also slightly more mute. Of course all photography is mute, but your previous work conjured up sounds of passing cars or anxious voices.

RBL: The newer work is not mute. You just have to listen more carefully. Its just not as loud.

DC: The American photographer Robert Adams once said "Still photographs often differ from life more by their silence than by the immobility of their subjects. Landscape pictures tend to converge with life however on summer nights when the sounds outside, after we call the children in and close the garage doors, are the small whirr of moths and the snap of a stick."

RBL: Hmmm...

DC: Obviously there's a sort of American rural romanticism in there, but the idea of a picture taken of a silent world is perhaps more realistic than a photograph that shuts off noise. The silence of photography is consonant with a silent world.

RBL: I'm not sure. That's debatable. But within my work of course it's all taken at night, which has a very different level of silence or noise.

DC: It's a John Cage-like idea that the quieter things are the more significant the sound. This would run counter to Adams. Do you want to say something about the significance of the river coming up again and again in this new work?

RBL: Hölderlin had some interesting ideas about the river. The river is this wonderful moving entity, which combines places and joins them up together and brings them to the sea. Hölderlin understood the river in a relationship to the sky, through the reflection of the sky in the water joining the two different elements together. For him the river was almost a receptacle of the gods. Do the gods come down through reflection and the rain?

DC: Water at night is a very powerful image.

RBL: It suggests an immersion. In my past work I was very much interested in vertiginous sensations. In this work I am much more interested in the sensation of immersion. Of course the river reflects... so it has this curious relation to photography. Water appears in another image called *Feuchte Blätter* or *Moist Sheets*. In German the word has a double meaning again. *Blätter* means leaves on a tree but also sheets, perhaps waiting for the text.

DC: You have found nature in the city.

Rut Blees Luxemburg, *Feuchte Blätter/Moist Sheets*, 1998.

RBL: In my new work nature dictates a lot of the photographs. I have to wait for rains or tides.

DC: This is a big break from the permanences of the world of concrete and steel that characterised *London: a Modern Project*. The newer work is more intimate. It welcomes nature and looks to the ephemeral.

RBL: Well the ephemeral did surface in *A Modern Project*, usually in the lights on buildings that would go on and off according to people moving around.

DC: Now then, you've brought me to a rather swish but smelly public toilet. We've paid 20 pence and now we've entered one of the city's more intimate spaces! You've made an image of a very similar space.

RBL: Yes. The image is called *Orpheus' Nachtspaziergang* or *Orpheus' Nocturnal Walk*. This isn't an ordinary toilet. It's one of these modern generic city toilets, a capsule. I think as an image it is very lush, which I like. These toilets have never been successful. No-one dares to use them. I don't use them! But I like the privacy they offer within the city. In a very public situation you suddenly have this incredible privacy.

DC: And the marbles and metals of this interior are so similar to the cafes springing up all over the city.

RBL: Absolutely. But it feels strange. I like the beautiful round mirror. I shot it from the outside glimpsing the inside, from the position of a walker. And as Nietzsche said "Only the thoughts formed during motion are worthwhile."

DC: Let's return to this idea of the walking poet in contrast to the *flâneur*. For Hölderlin, or the poet, walking involves responding to the world around them while being wrapped up in, or preoccupied with, other thoughts.

RBL: In a way, the motion of walking induces a certain state of mind. It's not dream-like, but it is almost meditative. So shall we walk a bit further?

DC: We are looking down at a tennis court you turned into a photograph titled *Corporate Leisure*.

RBL: The tennis court is on top of a building owned by de Beers, the diamond merchants.

DC: It's in one of those courtyard spaces that exist around the back of the impenetrable looking facades

Rut Blees Luxemburg, *Orpheus' Nachtspaziergang/ Orpheus' Nocturnal Walk*, 1999.

Rut Blees Luxemburg, *Corporate Leisure*, 1997.

W

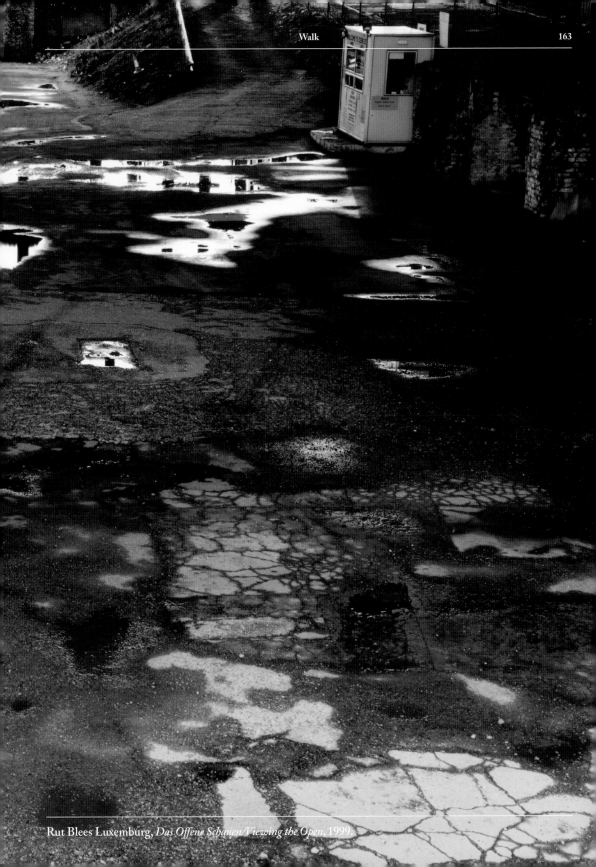

Rut Blees Luxemburg, *Das Offene Schauen/Viewing the Open*, 1999.

of so many big London buildings. How did you come to be here?

RBL: I think the impenetrability of the city is more of an illusion than a reality. You can actually find access to these places and enter them. This has been very important for my work—penetrating sites that at first suggest inaccessibility. What is so frightening about these places is the future they suggest—the fortress and the control that emanates from it. But I think they can be entered.

DC: The glass facade of the city is not so much transparent as it is reflective, bouncing back the gaze and reflecting the city around it. It offers itself as a spectacle of power that precludes entry, but as you point out, by bringing me here, the city isn't quite as impenetrable as it seems. How do you feel about the surveillance cameras? From where we are here I can count about seven or eight.

RBL: Well, as you've seen the cameras are not as effective as they suggest. They didn't pick us up. This is the attitude one can develop in relation to surveillance. It is more a myth than a reality. If the urban dwellers let the surveillance camera dictate movement around the city, they might as well stay at home.

DC: We've arrived at what looks like a shallow excavation site. I guess a building once stood here but now it is being used temporarily as a car park. You made an image here called *Das Offene Schauen* or *Viewing the Open*. It is a cinematic image, something like an establishing shot. Frame shape varies a good deal across your work. Does the cropping come afterwards or at the act of taking?

RBL: It varies, as the image requires. This place felt something like a Western in a way, with a swooping panoramic expanse. A vista.

DC: Questions about the medium of photography and related technical matters have surfaced already in our conversation. Now, I have this sense that the serious amateur, in coming to grips with the medium, encounters the long exposure as probably the first 'trick', the first magical bit of photography, where the camera itself is helping to produce an estranging effect. It is giving a kind of duration that is longer than normal, producing its own forms in the image. And on that level there is something about all long exposure night photography that contains something of the fascination that the serious amateur has with the camera itself.

RBL: Well for me it's not so much a fascination with photography but a fascination with the possibilities of the large format camera and the long exposure which allows me to let chance enter the work. The long exposure leaves space for unexpected things to happen while the shutter is open. So contingency is a big part of my way of taking images, of letting in that which is outside of my control.

DC: This is an interesting way to use a large format camera, which we usually associate with the height of control and pre-meditation.

RBL: The serious amateur would be horrified by certain results I get in terms of colour balances and uncorrected perspectives.

DC: There is always something in your work about on the one hand being very controlled but on the other letting chance happen within that control. This is somehow quite similar to your overall strategy of walking through the city at night and seeing what happens. It is a framework in which new possibilities can arise.

RBL: I set my own constraints, but they are open for whatever can happen.

DC: The street photographer whom we mentioned earlier has historically shot an awful lot of image, and probably a lot of awful images, to get what they want. You don't work this way.

RBL: No. I edit before I shoot which means I take a very deliberate number of photographs. The consideration and the chance come before taking the image and during the image but not afterwards. For me it is much more interesting to concentrate on less, and perhaps in one image enough happens to keep you engaged for a longer period instead of moving onto other images.

DC: That means you have an output that parallels a painter more than a photographer. And you also make preliminary studies, which is quite a painterly activity, as a way of preparing or pre-editing before committing to the time and expense of a big image. Are there many images that don't make it to the final stage?

RBL: Yes. Not many but there are a few. But
sometimes I go back to them and think about
them again.

DC: Could you talk a little about titles of your
photographs?

RBL: The titles open up the work for another
reading. These other readings are often literary,
or mythical or allegorical.

DC: Again this is more like a painter than a
photographer. Let's take an image like *Mount
Pleasant*, a beautiful image of some rather savage
metal fence work running along a high wall.

RBL: It was taken in Mount Pleasant, but the
name is also evocative of another sensation. In
the *Liebeslied* images I've gone back to German.
Not intentionally, but somehow it came over
me to use them, because often the German
words have the quality of being equivocal, and
in translation a gap opens and another layer of
meaning becomes possible.

DC: This plays against how mass culture puts image
and text together to clarify, to contain what Allan
Sekula once called the "fragmentary, incomplete
utterance" of the photograph.

RBL: Yes, but my titling is not an obscure act.
It is something which opens up something else.

DC: Would you want to say something about the
erotics of the work?

RBL: No. I leave that to the interpreter.

Rut Blees Luxemburg, *Mount Pleasant*, 1997.

Whippet

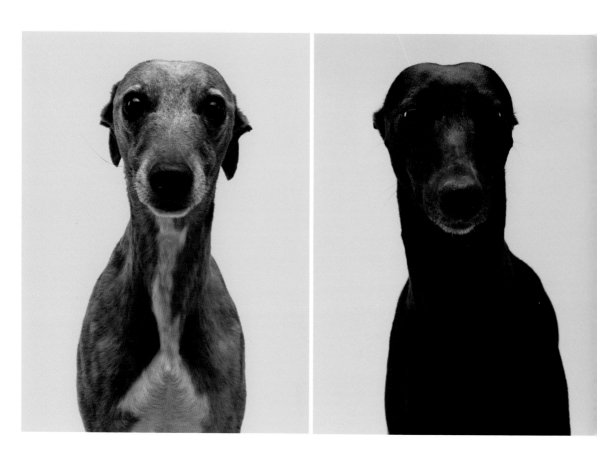

Jo Longhurst, *I know what you're thinking*, 2002–2003.

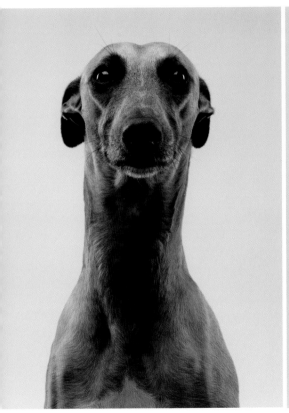 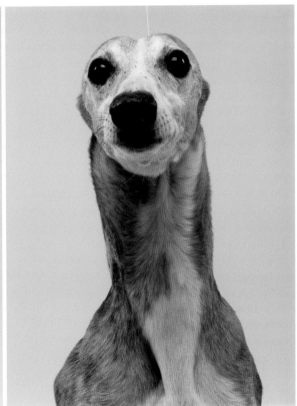

Dogs are not an alibi for other themes...
Dogs are not surrogates for theory; they are not just
here to think with. They are here to live with.

Donna Harraway, *The Companion Species Manifesto:
Dogs, People, and Significant Otherness*, 2003.

Window

Since the Renaissance, the Western perspective picture has been defined as a metaphorical window, through which we view the world. In the twenty-first century the photographic image can no longer be regarded as a window to the world, but rather, must now be thought of as structuring reality. Our contemporary environments are both composed of, and seen through, images. These images-for-consumption have replaced pictures-for-contemplation to such an extent that we no longer see through the window to the world. It has been wallpapered over with a myriad of screens, pages and images that constantly frame and re-frame our experiences, constructing our world for us.

Mark Bolland, *Statement*, 2011.

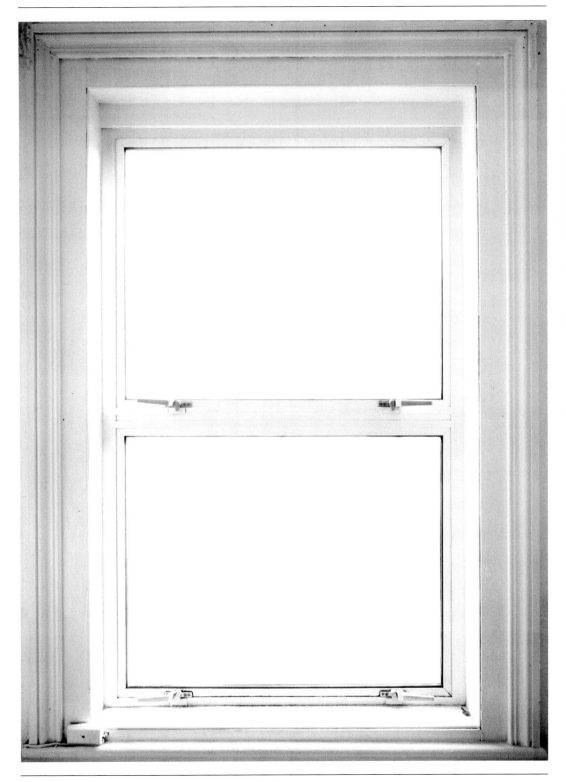

Mark Bolland, *White Window*, 2003.

top/ Mark Bolland, *Gold Hill*, 2006.
bottom/ Mark Bolland, *Train Window*, 2005.

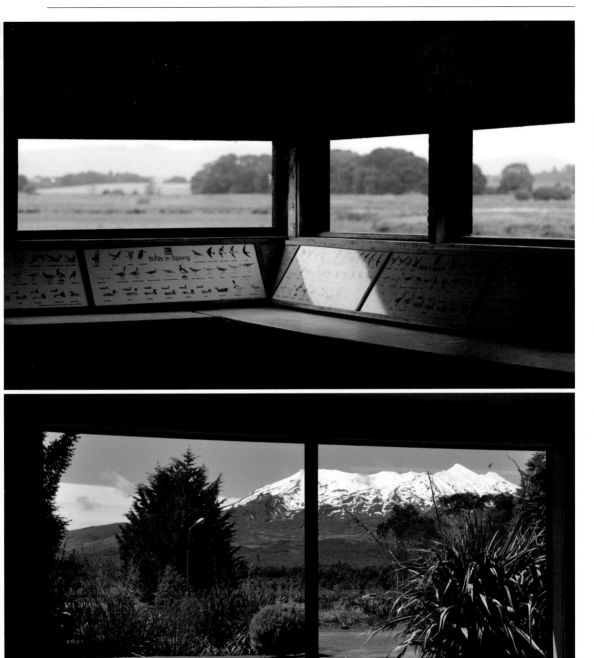

top/ Mark Bolland, *Hide*, 2008.
bottom/ Mark Bolland, *Picture Window*, 2009.

W

Mark Bolland, *Lattice Window*, 2007.

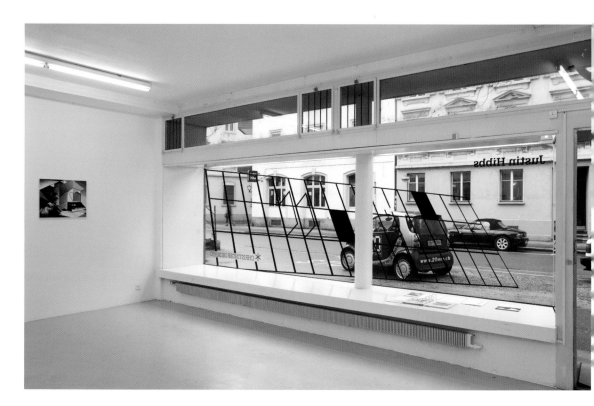

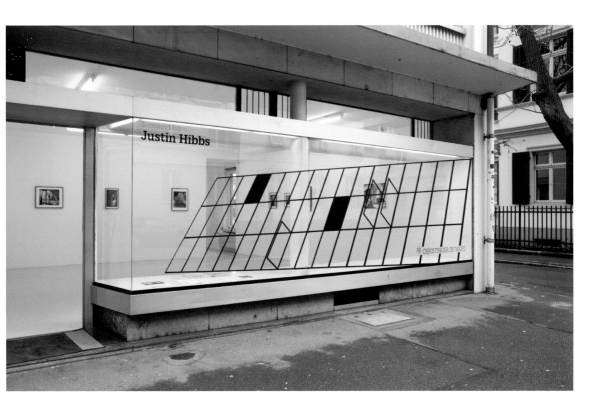

opposite and above/ Justin Hibbs, *Countervail*, 2010.

Work of Art

The Work of Art in the Electronic Age (1988)

The Work of Art in the Age of Post-Mechanical Reproduction (1990)

The Work of Art in the Age of Digital Reproduction (1995)

The Work of Art in the Age of Electronic (Re)Production (1998)

The Work of Art in the Age of Systematic Re-institutionalization (2001)

The Work of Art in the Age of Curatorial Production (2002)

The Work of Art in an Age of Diversity and Globalization (nd)

The Work of Art in the Age of Cyber Technology (nd)

The Digital Work of Art in the Age of Immaculate and Promiscuous Reproduction (nd)

The Work of Art in the Age of Mechanical Destruction (nd)

David Evans, *Recent Works*, 2011.

Karen Knorr, *The Work of Art in the Age of Mechanical Reproduction*, 1988.

XXX

Seven months before September 11, a widely quoted newspaper report had claimed that bin Laden's followers were operating a communications network based on encrypted messages concealed inside pornographic pictures. This technique, steganography, hides a coded message inside a picture or music file by making numerous small changes to data. The changes are invisible to ordinary viewers or listeners but can be read by special software.

The allegation that plans had been hidden inside Internet porn has, so far, proven unsupported. A few days before the attack, a team from the University of Michigan reported they had searched for images that might contain terror plans, using a network of computers to look for the "signature" of steganography. According to researchers at the Center for Information Technology Integration, they "analysed two million images… but have not been able to find a single hidden message."

Al Gebra, *XXX*, 2005.

YouTube

1/
Terror suspects held at Guantanamo Bay were shown execution photos of former Iraqi leader Saddam Hussein, a US lawyer claimed today. Joshua Dratel, acting for Australian detainee David Hicks, 31, who was captured in Afghanistan in 2001, said the images were used to intimidate prisoners.

2/
Mobile phone footage of Saddam Hussein's execution is being circulated as the latest playground craze.

Al Gebra, *YouTube*, 2007.

ZG

In 1982, *ZG* magazine produced a video entitled *ZG Presents*. It begins with a voice-over recording of Jack Goldstein's own first-person writing accompanying a slide presentation of the artist's work, interspersed with images of a distinctly 1980s corporate cityscape: think mirrored high-rise buildings and windowless board rooms. In a voice that is not his own, Goldstein positions his work as a response to a culture that, he says, "manipulates and controls you". That culture is an "artificial reality", Goldstein insists, and in relation to its illusion we might think of Goldstein as playing the role of the child who, by simply pointing out the obvious—that the emperor isn't actually wearing any clothes—strips the emperor bare, and in so revealing him naked and in the flesh neutralises the control he has over his subjects. By pausing, repeating, re-framing—in short, controlling and manipulating—the culture that controls and manipulates him, Goldstein moves to similarly strip his own emperor naked, unveiling the fragile machinery of the illusion of power it creates and thus breaking its seemingly magical hold.

The convergence of Jack Goldstein and *ZG* magazine was more than a coincidence; or, in fact, perhaps that is precisely what it was: a coincidence, a moment of synchronicity, a question of timing. Timing, after all, is what *ZG* magazine was all about. *ZG* magazine identified an urgent necessity in the very particular moment of its appearance—the Reagan years, the beginning of the AIDS epidemic, the post-punk years, the Wall Street boom—and responded to it. Like Goldstein, *ZG* paused, repeated, and above all re-framed the culture of power, but with text. By taking the objects of its analyses from high and low culture, popular and elite, it exposed the singular formal language, a sinister incantation, in which a Madonna concert and an art exhibition spoke their very different content. Like Goldstein, the magazine adopted a passive posture. It worked with what it was given. Its tone, accordingly, was neutral and analytical, deferring to what it revealed.

ZG magazine did not set out to spark a revolution or topple an empire—thereby becoming the empire that replaces the empire—but only to provide a gentle counterbalance, and this modesty, as much as anything else, opened between here and there, or them and us, the possibility of a third way. Perhaps it

is characteristic of what follows that third way to stay only just as long as it is needed, and return only when it is needed again. By 1986 *ZG* magazine had gone into hibernation, and nearly 20 years later it is not hard to see why.

It has long since ceased to constitute an act of resistance—even a gentle one—to reveal the machinery of power, because power has long since taken to doing this itself. This is evident not simply in the ways in which popular television, as one example, has integrated the techniques—rapid playback, voice-over commentary, pause and repetition—of 1980s artists like Richard Prince, Dara Birnbaum and Sherrie Levine, but indeed more disturbingly in the manner in which the Bush presidential administration revelled in constant revelations of deceptions and double-talk by way of which it created its flickering illusions. The apparent inability of such exposure to reduce its power only strengthened the illusion of its invincibility.

Thus, in the era of the Iraq war, reality television, real estate speculation, Britney Spears and Paris Hilton, a new necessity emerged: to find a useful form of action with which to resist the culture of power that manipulates and controls us. So far, it has been difficult. Before the beginning of the Iraq war, more people took to the streets at one time than had ever done so during Vietnam, but the volume of protesters only served to demonstrate the impotence of their action. Why should we be surprised? To place one's bet on the value of volume or force, on the strength of sheer numbers, is to accede in advance to the terms of the very culture of power one hopes to resist.

More than 20 years ago, *ZG* magazine gambled a credibility it had not yet established in order to demonstrate that power, which always presents itself in the guise of this content or that—a pop song, a television show, a war, an art auction—is in fact a structure, a machinery, an architecture, a single form. To simply reveal this, passively, was in that moment sufficient. Now, action's only hope is to learn its lesson from the past: if power is a form, then every useful act of resistance must operate on the level of form, as well. It is not nearly good enough to say something different than what power says, even something seemingly contradictory; rather, one must be something different, one must act differently.

Rosetta Brooks, *ZG*, 2010.

Biographies

Miquel Barceló/ Spanish painter and ceramicist whose work is marked by extended visits to Mali.

David Bate/ Writer. Photographer. Teacher. He is Reader in Photography at the University of Westminster, London, and leads the MA in Photography.

Benjamin Beker/ Photographer: born in Bonn, raised in Belgrade, and now based in London.

Sibylle Bergemann/ (1941–2010). She is linked to 'subjective photography' in the former German Democratic Republic and was included in Do Not Refreeze, an important 2007 exhibition, curated in England, about photography in the GDR.

Rut Blees Luxemburg/ Photographer and Tutor on the MA Photography programme at the Royal College of Art, London. She has published three monographs with Black Dog Publishing.

Mark Bolland/ Photographer. He lives in Wellington and teaches at the University of Massey.

Bertolt Brecht/ (1898–1956) Poet. Playwright. Pedagogue.

Candice Breitz/ Artist: born in South Africa, educated in the United States, and now based in Germany. Her studio is in Berlin and she is a Professor of Fine Art at the Braunschweig University of Art.

Rosetta Brooks/ Writer and founding editor of *ZG* magazine. She currently lives in California and recently launched ZgPress.

Adam Broomberg and Oliver Chanarin/ London-based photographers who regularly challenge the conventions of documentary photography.

Bianca Brunner/ Photographer who lives and works in Zurich.

David Campany/ Writer. Photographer. Teacher. He is Reader in Photography at the University of Westminster, London.

Common Culture/ Ian Brown is Senior Lecturer in Fine Art at Staffordshire University; David Campbell is Professor of Fine Art at Northumbria University; Mark Durden is Professor of Photography at the University of Wales, Newport.

Simon Cunningham/ Photographer. He currently lives and works in Edinburgh.

Omar D/ Photographer who divides his time between Algiers and Paris.

Guy Debord/ (1931–1994) Writer. Film director. Troublemaker.

Paola Di Bello/ Artist, Milan.

Patrizia Di Bello/ Lecturer in the History and Theory of Photography at Birkbeck College, University of London.

Tim Edgar/ Photographer based in Swanage, Dorset. He teaches at the Arts University College at Bournemouth.

Christian Edwardes/ He teaches Fine Art at the Arts University College at Bournemouth and is currently completing his practice-based PhD at Chelsea College of Art, London.

Ed van der Elsken/ (1925–1990). Dutch photographer whose book *Love on the Left Bank*, 1954, was continuously referenced by Guy Debord.

David Evans/ Secretary of *criticaldictionary.com*.

Martin Evans/ Professor of Contemporary History at the University of Portsmouth, specialising in Franco-Algerian relations.

Al Gebra/ No details.

Katherine Gillieson/ Designer, writer, and lecturer in the Department of Typography at the University of Reading.

Paul Graham/ Photographer. A major retrospective was held at the Whitechapel Gallery, London, in 2011.

Brian Griffin/ Photographer, London.

Dave Hazel/ Leader of the BA (Hons) Photography programme, Arts University College at Bournemouth.

Justin Hibbs/ Artist, London.

Asger Jorn/ (1914–1973) Danish artist who worked closely with Guy Debord in the 1950s.

Karen Knorr/ Professor of Photography at the University for the Creative Arts, Farnham. She is represented by James Hyman Photography, London. A survey of her career was published by Black Dog Publishing in 2002.

Laibach/ Artists. Musicians. Provocateurs. They are based in Slovenia.

Ann Lee/ Berkeley, California. Otherwise, no details.

Hew Locke/ Artist, represented by Hales Gallery, London. A monograph has recently been published by Black Dog Publishing.

Tammy Lu/ Artist, currently teaching at the University of Saskatchewan.

Julie Marsh/ Artist filmmaker. She teaches at the Arts University College at Bournemouth and is enrolled for a practice-based PhD at The London College of Communication.

Dominik Mentzos/ Photographer, Frankfurt. He regularly does production shots for the William Forsythe Dance Company, based in Frankfurt.

Åsa Maria Mikkelsen/ Photographer, Oslo.

Heiner Müller/ (1929–1995) Poet. Playwright. Post-Brechtian.

Office of Experiments/ Steve Rowell and Neal White. They recently launched their Overt Research Database.

Gavin Parkinson/ Art historian. Critic. Experimental writer. He teaches at the Courtauld Institute, University of London.

Ivan Petrovic/ Photographer, Belgrade.

Poor Photographer/ No information.

Frédérique Poinat/ Writer. She is a specialist on Hervé Guibert and is currently preparing a new book on the politics of family albums.

Marcia Pointon/ Emeritus Professor of Art History at the University of Manchester and the Courtauld Institute, University of London.

Maja Ratkje/ Musician, Oslo, who records for various labels including Rune Grammofon.

Minna Rainio and Mark Roberts/ Photographers and filmmakers, based in Rovaniemi, Finland. Minna has recently been a Visiting Professor of Photography at the University of Minnesota, Minneapolis.

Retort/ An informal group of dissident artists and intellectuals, based in the Bay area of San Francisco.

Dominic Shepherd/ Painter based in Dorset, represented by the Charlie Smith Gallery, London.

Christopher Stewart/ Photographer, represented by Gimpel Fils, London. He leads the Photography programme at the National Art School, Sydney.

Birgitte Sigmundstad/ Photographer and filmmaker, Oslo.

Jo Spence/ (1934–1992) Socialist Feminist photographer, writer and pedagogue. A major solo exhibition was held at MACBA, Barcelona, in 2005.

John Stezaker/ Artist, represented by The Approach Gallery, London. A retrospective devoted to his collages was held at the Whitechapel Gallery, London, in 2011.

Penelope Umbrico/ New York-based photographer. A monograph was published by Aperture in 2011.

Jake Walters/ Photographer, London. He is particularly noted for his portraits of musicians in *The Wire*, and regularly does production shots for the Michael Clark Dance Company.

Bibliography

• **Ades Dan and Baker, Simon/** *Undercover Surrealism: Georges Bataille and DOCUMENTS*, London and Cambridge, Mass.: The Hayward Gallery and MIT Press, 2006.

• **Barceló, Miquel and Moral, Jean Marie del/** *Barceló*, Göttingen: Steidl, 2004.

• **Bate, David/** *Photography & Surrealism: Sexuality, Colonialism and Social Dissent*, London: IB Tauris, 2004.

• **Bate, David/** *Photography: The Key Concepts*, Oxford and New York: Berg, 2009.

• **Baudrillard, Jean/** *The Transparency of Evil: Essays on Extreme Phenomena*, London and New York: Verso, 1993.

• **Beker, Benjamin/** *Monuments*, Sway: Artsway, 2009.

• **Blees Luxemburg, Rut/** *London: A Modern Project*, London: Black Dog Publishing, 1997.

• **Blees Luxemburg, Rut/** *Liebeslied: My Suicides*, London: Black Dog Publishing, 2000.

• **Blees Luxemburg, Rut/** *Commonsensual: The Works of Rut Blees Luxemburg*, London: Black Dog Publishing, 2009.

• **Bois, Yve-Alain and Krauss, Rosalind/** *Formless: A User's Guide*, New York: Zone Books, 1997.

• **Bradley, Will and Esche, Charles, eds/** *Art and Social Change: A Critical Reader*, London: Afterall, 2007.

• **Brecht, Bertolt/** *War Primer*, London: Libris, 1998.

• **Breitz, Candice/** *Re-animations*, Oxford: Museum of Modern Art, 2003.

• **Brooks, Rosetta/** 'Rip It Up, Cut It Off, Rend It Asunder' in Mark Sladen, Ariella Yedgar, eds, *Panic Attack! Art in the Punk Years*, New York: Merrell Publishers, 2007.

• **Broomberg, Adam and Chanarin, Oliver/** *Chicago*, Göttingen: SteidlMACK, 2006.

• **Broomberg, Adam and Chanarin, Oliver/** *The Red House*, Göttingen: SteidlMACK, 2006.

• **Brunner, Bianca/** *Gap in the Real*, Zurich: Scheidegger & Spiess AG, 2010.

• **Bryant, Levi/** *The Democracy of Objects*, openhumanitiespress.org, 2011.

• **Campany, David/** *Photography and Cinema*, London: Reaktion Books, 2009.

• **Campany, David/** *Walker Evans: The Magazine Work*, Göttingen: Steidl, 2011.

• **Campbell, David and Durden, Mark/** *Variable Capital*, Liverpool: University of Liverpool Press, 2009.

• **Chéroux, Clément/** *Fautographie: Petite histoire de l'erreur photographique*, Crisnée: Éditions Yellow Now, 2003.

• **D, Omar/** *Devoir de mémoire / A Biography of Disappearance, Algeria 1992–*, London: Autograph ABP, 2007.

• **Debord, Guy/** *Panegyric 1 and 2*, London and New York: Verso, 2004.

• **Di Bello, Patrizia/** *Women's albums and photography in Victorian England: ladies, mothers and flirts*, Aldershot: Ashgate, 2007.

• **Di Bello, Patrizia and Koureas, Gabriel, eds/** *Art, history and the senses: 1830 to the present*, Aldershot: Ashgate, 2010.

• **Didi-Huberman, Georges/** *La ressemblance informe : ou le gai savoir visuel selon Georges Bataille*, Paris: Éditions Macula, 1995.

• **Didi-Huberman, Georges/** *Confronting Images: Questioning the Ends of a Certain History of Art*, University Park, PA: The Penn State University Press, 2005.

• ***Documents* 1929–30/** Facsimile edition, Paris: Éditions Jean-Michel Place, 1991.

• **Edgar, Tim/** *Rookery*, Bournemouth: Text and Work, The Arts Institute at Bournemouth, 2003.

• **Edwardes, Christian and Hall, Tom/** *Borderlands*, Bournemouth: Text and Work, Arts Institute at Bournemouth, 2008.

• **Elsken, Ed van der/** *Love on the Left Bank*, Stockport: Dewi Lewis, 1997.

• **Evans, David, ed./** *Appropriation*, London and Cambridge, Mass.: Whitechapel Gallery and MIT Press, 2009.

• **Evans, Martin and Phillips, John/** *Algeria: Anger of the Dispossessed*, London and New Haven: Yale University Press, 2007.

• **Evans, Martin/** *Algeria: France's Undeclared War*, Oxford: Oxford University Press, 2011.

• **Ford, Simon/** *The Situationist International: a user's guide*, London: Black Dog Publishing, 2005.

• **Graham, Paul/** *End of an Age*, New York and Zurich: Scalo, 1999.

• **Graham, Paul/** *Beyond Caring*, New York: Errata Editions, 2011.

• **Graham, Paul/** *Paul Graham*, Göttingen: SteidlMACK, 2011.

• **Griffin, Brian/** *BRIANGRIFFININFLUENCES*, Rejkjavik: The Rejkjavik Art Museum, 2005.

• **Guibert, Hervé/** *Ghost Image*, Los Angeles: Sun & Moon Press, 1996.

• **Harraway, Donna/** *The Companion Species Manifesto: Dogs, People, and Significant Otherness*, Chicago: Prickly Paradigm Press, 2003.

• **Hiorthøy, Kim/** *Money Will Ruin Everything*, Oslo: Rune Grammofon, 2003.

• **Hiorthøy, Kim/** *Money Will Ruin Everything 2*, Oslo: Rune Grammofon, 2008.

• *Internationale Situationniste* **1958–1969/** Facsimile edition, Paris: Éditions Champ Libre, 1975.

• **IRWIN, ed./** *East Art Map: Contemporary Art and Eastern Europe*, London: Afterall, 2006.

• **Jameson, Frederick/** *Brecht and Method*, London and New York: Verso, 1998.

• **Jappe, Anselm/** *Guy Debord*, Berkeley: University of California Press, 1999.

• **Jorn, Asger and Debord, Guy-E/** *Fin de Copenhague*, Paris: Éditions Allia, 1998.

• **Jorn, Asger and Debord Guy-E/** *Mémoires*, Paris: Éditions Allia, 2004.

• **Jünger, Ernst/** 'Über die Gefahr' in Ferdinand Buchholtz ed., *Der gefährliche Augenblick: eine Sammlung von Bildern und Berichten*, Berlin: Junker und Dünnhaupt Verlag, 1931, pp. 11–16.

• **Knorr, Karen/** *Genii loci*, London: Black Dog Publishing, 2002.

• **Lee, Ann/** *Appropriation: A Very Short Introduction*, lulu.com, 2008.

• *Les Lèvres Nues*, **1954–1958/** Facsimile edition, Paris: Éditions Plasma, 1978.

• **Locke, Hew/** *Stranger in Paradise*, London: Black Dog Publishing, 2011.

• **Longhurst, Jo/** *The Refusal*, Essen: Museum Folkwang; Göttingen: Steidl, 2008.

• **Marsh, Julie and Bonnell, Peter/** *Into the Light*, Bournemouth: Text and Work, The Arts Institute at Bournemouth, 2007.

• **McDonough, Tom/** *The Beautiful Language of My Century: Reinventing the Language of Contestation in Postwar France, 1945–1968*, Cambridge, Mass. and London: The MIT Press, 2007.

• **McDonough, Tom ed./** *The Situationists and the City: A Reader*, London and New York: Verso, 2010.

• **Monroe, Alexei/** *Interrogation Machine: Laibach and NSK*, London and Cambridge, Mass.: MIT Press, 2005.

• **Müller, Heiner and Bergemann, Sibylle/** *Ein Gespenst verlässt Europa*, Cologne: Kiepenheuer & Witsch, 1990.

• **Oever, Annie van den, ed./** *Ostrannenie*, Amsterdam: University of Amsterdam Press, 2010.

• **Office of Experiments/** *Dark Places*, Southampton: John Hansard Gallery, University of Southampton, 2010.

• **Parkinson, Gavin/** *Surrealism, Art and Modern Science: Relativity, Quantum Mechanics, Epistemology*, London and New Haven: Yale University Press, 2008.

• **Parkinson, Gavin/** *The Duchamp Book*, London: Tate Publishing, 2008.

• **Perec, Georges/** *Species of Spaces and Other Pieces*, Harmondsworth: Penguin, 1997.

• **Poinat, Frédérique/** *L'œuvre siamoise. Hervé Guibert et l'expérience photographique*, Paris: L'Harmattan, 2008.

• **Pointon, Marcia/** *Brilliant Effects: a Cultural History of Gem Stones and Jewellery*, London and New Haven: Yale University Press, 2009.

• **Rainio, Minna and Roberts, Mark/** *Faster than History: a contemporary perspective on the future of art in the Baltic countries, Finland and Russia*, Helsinki: Kiasma Museum of Contemporary Art, 2004.

• **Retort/** *Afflicted Powers: Capital and Spectacle in a New Age of War*, London and New York: Verso, 2005.

• **Shepherd, Dominic and Parkinson, Gavin/** *Mycelium*, Bournemouth: Text and Work, The Arts University College at Bournemouth, 2010.

• **Silberman, Marc, ed./** *Bertolt Brecht on Film and Radio*, London: Methuen, 2000.

• **Six/** Tokyo: Comme des Garçons, 1988–1991.

• **Spence, Jo/** *Putting Myself in the Picture: A Political, Personal and Photographic Autobiography*, London: Camden Press, 1986.

• **Spence, Jo/** *Cultural Sniping: The Art of Transgression*, London and New York: Routledge, 1995.

• **Spence, Jo/** *Beyond the Perfect Image. Photography, Subjectivity, Antagonism*, Barcelona: MACBA, 2005.

• **Stewart, Chris/** *Insecurity Series 1995–2001*, London: Gimpel Fils, 2002.

• **Stewart, Chris/** *Christopher Stewart*, Salamanca: Centro de Arte de Salamanca, 2003.

• **Stezaker, John/** *Silkscreens*, London: The Approach and Ridinghouse, 2010.

• **Stezaker, John/** *John Stezaker*, London: The Whitechapel and Ridinghouse, 2011.

• **Stoekl, Allan, ed./** *Georges Bataille, Visions of Excess: Selected Writings 1927–1939*, Minneapolis: University of Minnesota Press, 1985.

• **Umbrico, Penelope/** *Photographs*, New York: Aperture, 2011.

• **Virilio, Paul/** *Unknown Quantity*, London and New York: Fondation Cartier pour l'art contemporain and Thames & Hudson, 2003.

• **Walker, Ian/** *City Gorged with Dreams: Surrealism and Documentary Photography in Interwar Paris*, Manchester: Manchester University Press, 2002.

• **Wizisla, Erdmut/** *Walter Benjamin and Bertolt Brecht: The Story of a Friendship, 1924–1940*, London: Libris, 2008.

• **ZG/** London and New York, 1981–1992.

Credits/
List of Works

6–7/ Martin Evans, *Algeria: A Little Biographical Dictionary*, 2008. © Martin Evans.

8–9/ Omar D, *Devoir de mémoire/A Biography of Disappearance, 1992–*, London: Autograph, 2007. Photographs courtesy Omar D and Autograph ABP, London.

10/ Candice Breitz, *Soliloquy (Sharon)*, 2000. Still courtesy Studio Breitz, Berlin.

11/ David Evans, *Wind from the East: One or Two Questions for Candice Breitz*, 2009. © David Evans and Candice Breitz.

12-15/ David Evans, *A Conversation with Ann Lee*, 2009. © David Evans and Ann Lee.

16/ David Campany, *Bed*, 1995. Courtesy the photographer.

17/ Birgitte Sigmundstad, *Philosophy in the Boudoir*, 1999. Courtesy the photographer.

18–23/ Chris Stewart, *Super Border*, 2009. Courtesy the photographer.

20–23/ Mark Roberts and Minna Rainio, *Borderlands*, 2004. Courtesy the photographers.

24–25/ Asger Jorn and Guy-E Debord, *Fin de Copenhague*, 1957. Courtesy David Evans Collection.

27–29/ Paula Di Bello, *La Disparition*, 1994. Courtesy the artist.

30–31/ Christian Edwardes, *North-West Passage*, 2006. Courtesy the artist.

32/ Poor Photographer, *Civilisation*, 1998. Courtesy the artist.

33–37/ Brian Griffin, *Untitled*, 1990. Courtesy the photographer.

37/ David Evans, *Comme and Communism*, 2006. © David Evans.

38/ Anon, *The Final Moment*, in Ferdinand Buchholtz ed., *Der gefahrliche Augenblick: eine Sammlung von Bildern und Berichten*, Berlin: Junker und Dünnhaupt Verlag, 1931. Courtesy David Evans Collection.

39/ Found photographs, Paul Poinat Collection, 2011. Courtesy Paul Poinat.

40/ David Evans, *Détournement*, 2011. © David Evans.

41/ Cover, *Les Lèvres Nues*, no. 8, May 1956. Courtesy David Evans Collection.

42–43/ Paul Graham, *End of an Age*, 1999. Courtesy the photographer.

44–45/ David Evans, *Flaw Show*, 2005. © David Evans.

46/ Jo Spence, *The Family Album 1939 to 1979*, 1979. Courtesy Terry Dennett/Jo Spence Archive, London.

47–49/ David Evans, *Jo Spence Beyond the Family Album: a primer*, 2005. © David Evans.

50–51/ Tim Edgar, *Rookery*, 2003. Courtesy the photographer.

52–53/ Bianca Brunner, *Untitled*, 2006. Courtesy the photographer.

54–55/ Photograph and text from Adam Broomberg and Oliver Chanarin, *Chicago*, 2006. Courtesy the photographers.

56/ Frédérique Poinat, *Ghost Image*, 2011. © Frédérique Poinat.

57/ Miquel Barceló, *Belfegor* no. 4, 1990. © ADAGP, Paris and DACS, London, 2011.

59–61/ Dominik Mentzos, *Human Writes*, 2005. Courtesy the photographer.

62/ Al Gebra, *Humve(il)*, 2008. © Al Gebra.

63/ Simon Cunningham, *Duckrabbit*, 2011. Courtesy the photographer.

64–65/ David Evans, *Brilliant Effects: an interview with Marcia Pointon*, 2011. © David Evans and Marcia Pointon.

66–67/ Hew Locke, *Congo Man* (detail), 2007, from *Hew Locke: Stranger in Paradise*, London: Black Dog Publishing, 2011. © Hew Locke, courtesy Hales Gallery, London.

68/ David Evans, *Kanak*, 2011. © David Evans.

68/ *Documents* 4 (September 1929). Courtesy David Evans Collection.

69/ David Campany, *Labour*, 2011. © David Campany.

69/ Walker Evans, 'Labor Anonymous', *Fortune*, November 1946. Courtesy Time Inc. and The Metropolitan Museum of Art, New York.

70–71/ Tim Edgar, *Untitled*, 2010. Courtesy the photographer.

73–77/ Benjamin Beker, *1953 (Valjevo)*, 2008; *1995 (Beograd)*, 2009; *1981 (Kragujevac)*, 2008; *1961 (Kosmaj)*, 2008; *1980 (Sopot)*, 2008; *1968 (Kragujevac)*, 2008; *1967 (Golubac)*, 2008; *1999 (Valjevo)*, 2008; *2000 (Pozarevac)*, 2008.

78/ Gavin Parkinson, *Mycelium*, 2011. © Gavin Parkinson.

79/ Dominic Shepherd, *Golden Dawn*, 2010. Courtesy the artist.

80–85/ Christian Edwardes, *North, West, East, South*, 2008. Courtesy the artist.

87–89/ Jake Walters, *O Stravinsky Project Part 1*, 2005. Courtesy the photographer.

91/ Simon Cunningham, *Mollymuddle*, 2007. Courtesy the photographer.

92–97/ Office of Experiments, *Overt Research Project*, 2008–09. **92–93/** RAF Brunton/Farm, Beneath Low Flying Area 12; **94/** Abbot's Cliff Sound Mirror (top); Didcot Power Station, Children's Activity Centre (bottom); **95/** RAF Greenham Common, Former US Gryphon Cruise Missile Hangars (top); QinetiQ Foulness Island, Coast Approach (bottom); **96/** MI-5 Headquarters Entrance Gate (row 1, left); QinetiQ Foulness Island, Signage (row 1, right); QinetiQ Foulness Island, Broomway to Land (row 2, left); QinetiQ Foulness Island, Broomway to Sea Across Maplin Sands (row 2, right); AWE Burghfield, Crossroads Approach (row 3, left); AWE Burghfield, Trident Nuclear Warhead Assembly Site (row 3, right); Corsham Computer Centre, Barricaded Service Road (row 4, left); Corsham Computer Centre, Gated Entrance Road (row 4, right); **97/** Denge Sound Mirrors, Flooded Gravel Pit (row 1, left); GCHQ Cheltenham, Residential Ring (row 1, right); QinetiQ Defford SIGINT Enclave (row 2, left); RAF Fairford, US B-2 Stealth Bomber Hangars (row 2, right); HMGCC Hanslope Park, Training Radome (row 3, left); Giro's Grave, Former German Embassy (row 3, right); Air Raid Shelter, London (row 4, left); Dark Matter Research Facility, Boulby Potash Mine (row 4, right). All photographs Steve Rowell.

98/ David Evans, *Éliane: A Situationist Emblem*, 2004. © David Evans.

98–99/ Ed van der Elsken, *Love on the Left Bank*, 1954. © Ed van der Elsken/Nederlands Fotomuseum, Rotterdam.

100/ Al Gebra, *The Camera That Exploded and other minor détournements*, 2006. © Al Gebra.

101/ David Evans, *As Brecht Says...*, 2011. © David Evans.

102–103/ David Campany, *The Red House*, 2006. © David Campany.

104–107/ Adam Broomberg and Oliver Chanarin, *The Red House*, 2006. Courtesy the photographers.

108/ Rosetta Brooks, *Rip It Up, Cut It Off, Rend It Asunder*, 2007. © Rosetta Brooks.

109–111/ John Stezaker, *Untitled*, 1990. Courtesy the artist and The Approach Gallery, London.

112–117/ Retort, *Interview with Article XI*, 2009. Courtesy Iain Boal and Retort.

112–116/ Dominik Mentzos, *Clouds After Cranach*, 2006. Courtesy the photographer.

119/ Rut Blees Luxemburg, *Rotten Sunrise*, 2010. Courtesy the photographer.

120/ Julie Marsh, *Into the Light*, 2009. Courtesy the artist.

121/ Dominic Shepherd, *Black Sun*, 2008. Courtesy the artist.

122–123/ Dave Hazel, *Untitled*, 2005. Courtesy the photographer.

124–125/ Penelope Umbrico, *Flickr Sunsets*, 2010. Courtesy the photographer.

126/ David Evans, *Spectre*, 2011. © David Evans.

126/ Heiner Müller and Sibylle Bergemann, *Ein Gespenst Verlässt Europa*, 1990. © Verlag Kiepenheuer & Witsch, Cologne.

127/ David Evans, *Stone Breakers*, 2011. © David Evans.

127/ Poor Photographer, *The Stone Breakers*, 1989. Courtesy the artist.

128–129/ David Evans, *Fish in Pocket: an interview with David Bate*, 2004. © David Evans and David Bate.

130–133/ Penelope Umbrico, *Broken Sets*, 2002; *For Sale/ TVs from Craigslist*, 2009. Courtesy the photographer.

134–135/ Tammy Lu, drawing, and Katherine Gillieson, cover design, Levi Bryson, *The Democracy of Objects*, 2011. Courtesy the artists and Open Humanities Press.

136–137/ Anon, *Gold pendant containing a daguerreotype portrait and a lock of hair*, c. 1850. © Kodak Collection/NMeM /Science & Society Picture Library. All rights reserved.

136–137/ Patrizia Di Bello, *Touch*, 2011. © Patrizia Di Bello.

138/ Bertolt Brecht, *War Primer*, 1998. Editor/translator: John Willett. Courtesy Nicholas Jacobs, Libris, London.

138/ David Evans, *Umfunktionierung*, 2011. © David Evans.

139–143/ David Evans, *Variable Capital: a conversation with Common Culture*, 2008. © David Evans and Common Culture.

140–141/ Common Culture, *Binge*, 2007. Courtesy the artists.

142/ Common Culture, *Bouncers*, 2005. Courtesy the artists.

144–145/ Poor Photographer, *Vers une Architecture*, 2011. Courtesy the artist.

146–147/ Åsa Maria Mikkelsen, *Covering Maja Ratkje*, 2006. © Åsa Maria Mikkelsen and Maja Ratkje.

148–153/ Laibach, *Volk*, 2006. Courtesy the artists.

154–157/ Ivan Petrovic, *Night Promenade*, 2011. Courtesy the photographer.

158–165/ Rut Blees Luxemburg and David Campany, *Why don't we walk along the river? A Conversation*, 1997. © Rut Blees Luxemburg and David Campany.

158–161; 63, 165/ Rut Blees Luxemburg, *Liebeslied*, 1999; *Nach Innen/In Deeper*, 1999; *Feuchte Blätter/ Moist Leaves*, 1998; *Orpheus' Nachtspazierung/Orpheus' Nocturnal Walk*, 1999; *Corporate Leisure*, 1997; *Das Offene Schauen/Viewing the Open*, 1999; *Mount Pleasant*, 1997. Courtesy the photographer.

166–167/ Jo Longhurst, *I know what you're thinking*, 2002–03. Courtesy the photographer.

168/ Mark Bolland, *Statement*, 2011. © Mark Bolland.

169–173/ Mark Bolland, *White Window*, 2003; *Gold Hill*, 2006; *Train Window*, 2005; *Hide*, 2008; *Picture Window*, 2009; *Lattice Window*, 2007. Courtesy the photographer.

174–175/ Justin Hibbs, *Countervail*, 2010. Courtesy the artist and the Christinger De Mayo Gallery, Zurich. Photography: Martin Stollenwerk.

176/ David Evans, *Recent Works*, 2011. © David Evans.

177/ Karen Knorr, *The Work of Art in the Age of Mechanical Reproduction*, 1988. Courtesy the photographer.

178/ Al Gebra, *XXX*, 2005. © Al Gebra.

179/ Al Gebra, *YouTube*, 2007. © Al Gebra.

180/ Rosetta Brooks, *ZG*, 2010. © Rosetta Brooks.

181/ *ZG* covers. Courtesy David Evans Collection.

Acknowledgements

David Evans would like to thank all who have generously donated work both to the website *criticaldictionary.com* and to this publication. In addition, many thanks to the following for their support:

Hitesh Ambasna
Iain Boal
Andy Cope
Terry Dennett
Byron Evans
Peter Erdélyi
Max Fabian
James Hambly
Ronnie Inglis
Nicholas Jacobs
Indra Khanna
Nina Kirk
Duncan McCorquodale
James McNellan
Ivan Novack
Tom O Mara
Lucy Parker
Rachel Pfleger
Josette Poinat
Paul Poinat
Paul Roberts
Aaron Schumann
Mark Shufflebottom
Andy Touch
Karen Vanmeenen
Richard West
Charlotte Wilmot
Justin Windle
Rugile Zukaite

© 2011 Black Dog Publishing Limited,
the artists and authors.
All rights reserved.

Black Dog Publishing Limited
10A Acton Street
London
WC1X 9NG

t. +44 (0)207 713 5097
f. +44 (0)207 713 8682
e. info@blackdogonline.com

Designed by Rachel Pfleger at Black Dog Publishing.
Edited by David Evans.

British Library Cataloguing-in-Publication Data.
A CIP record for this book is available from the
British Library.

ISBN 978 1 907317 49 1

Black Dog Publishing is an environmentally responsible
company. *Critical Dictionary* is printed on FSC
accredited paper.

cover/ Jake Walters, *O Stravinsky Project Part 1*
(detail), 2005. Courtesy the photographer.

architecture art design
fashion history photography
theory and things

black dog
publishing

www.blackdogonline.com london uk